color your DREAMS

100 Inspiring Words,
Captivating Coloring Pages
& Uplifting Activities

D1404640

JULIET MADISON

sourcebooks

Published by Sourcebooks
P.O. Box 4410, Naperville, Illinois 60567-4410
(630) 961-3900
sourcebooks.com

Printed and bound in the United States of America.
POD

..........

CONTENTS

..........

INTRODUCTION

I HAVE WONDERFUL MEMORIES OF drawing and coloring as a child: the sound of pencils scratching gently on the paper, the burst of color as it grows into a bright picture. Both the act of coloring and the result always made me feel happy and accomplished. Coloring can be just as beneficial for adults as it is for children, as it allows you to switch off from the busy, technology-overloaded world and focus on the simplicity of the moment. Apart from using coloring as a relaxation tool, I've also used it to help me with my goals and dreams by allocating a specific color for each goal and focusing my mind on the goal as I color. Coloring is an enjoyable activity for all ages to de-stress and enrich life. My wish for you as you color the illustrations in this book is to achieve a positive state of well-being through relaxation, mindfulness, and joyful creative expression.

With the accompanying activity pages, you can also become more empowered and take steps to create your dream life by harnessing the power of positive intention and the law of attraction to bring you more of what you desire. Through the law of attraction, you attract into your life more experiences that match your thoughts and feelings. When you feel good, you are a magnet for positive experiences—like attracts like.

Start by coloring the illustrations with the words or themes that are most important in your life right now, or work through the book page by page. Some activity pages have coloring tips tailored to the associated theme to help you get the most out of each page.

Coloring the pictures and completing the activities in this book will help you to focus on positive aspects you wish to experience in your life. You attract more of the elements you focus on, so by deliberately paying more attention to what you want and what brings you joy, you can create a more fulfilling, happy life. In fact, you can *color your dreams*.

~ JULIET

To connect with Juliet, share your creations, and interact with other coloring enthusiasts, join the *Color Your Dreams* Facebook group by following the link at www.julietmadison.com.

> "Abundance is not something we acquire. It is something we tune into."
> ~ DR. WAYNE W. DYER

COLORING TIP

As you color the abundance tree, focus on what is already abundant in your life and give thanks for your blessings.

AFFIRMATIONS

Choose an affirmation and repeat several times daily, or during meditation:

1. I welcome unlimited abundance into my life.
2. I am worthy and deserving of financial abundance.
3. Abundance in all forms flows to me easily and continually.

THREE WAYS I AM ABUNDANT

List three things that prove you are abundant in a variety of areas including finance, love, joy, success, etc. *For example, I received a gift today, I was able to buy coffee, I found money, I received a hug, I had a good belly laugh with a friend.*

1. ...
2. ...
3. ...

To receive more abundance, you need to feel abundant already. Through the law of attraction you will attract more of what you think and feel. A focus on lack will produce more lack. Focus on what you have and what you have to give, and watch the abundance flow.

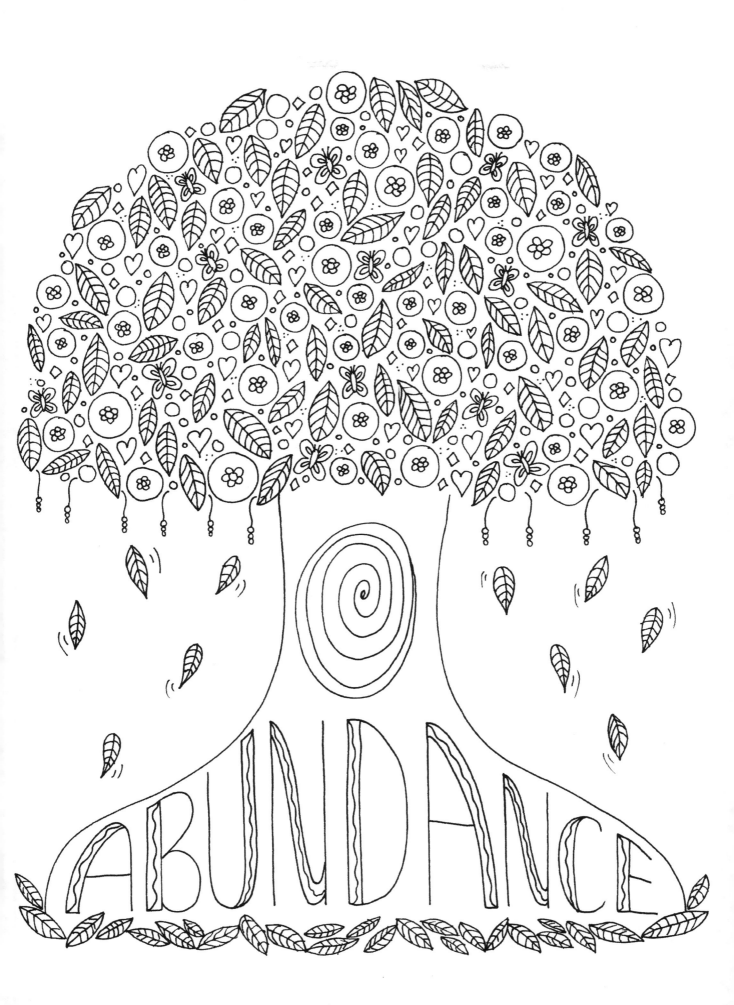

> "The greatest gift that you can give to others is the gift of unconditional love and acceptance."
> ~ BRIAN TRACY

COLORING TIP

As you color, feel at peace with where you are in life and how far you have come.

AFFIRMATIONS

Choose an affirmation and repeat several times daily or during meditation:

1. I accept myself as I am right now.
2. I accept where I am in my life and trust everything is working out for me.
3. I live each day with a calm acceptance of everyone and everything.

MINI MEDITATION

Get comfortable and close your eyes. Take several deep breaths. Feel your body in contact with the chair, bed, or floor.

As you relax further, focus on any part or parts of your body you wish. Imagine this area bathed in healing light that is the color of your choice. Visualize the area being filled with love and acceptance. Say "I love and accept you right now." You may wish to name the body part, or focus on your overall body, and say "I love and accept myself right now." Repeat this for as long as you like, on any areas of the body you feel the need to, then slowly open your eyes and continue with your day.

Acceptance doesn't mean giving in or resigning yourself to a life less than you desire. It means accepting things as they are right now and being okay with the present moment, knowing that everything is where it needs to be. Trust that anything is possible from this moment on and the best is yet to come.

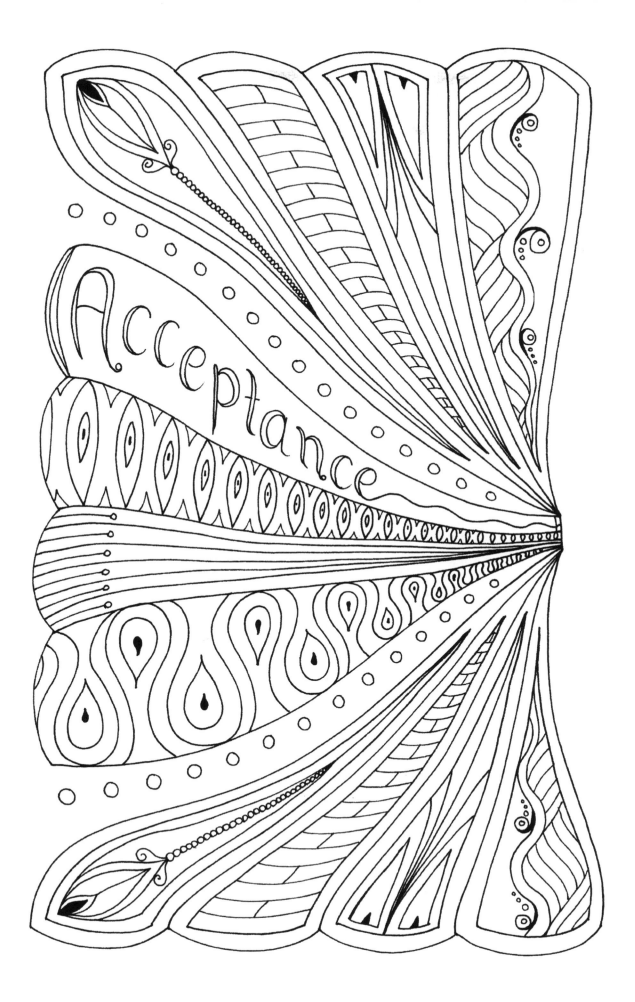

> "To be yourself in a world that is constantly trying to make you something else is the greatest accomplishment."
> ~ RALPH WALDO EMERSON

COLORING TIP

As you color each of the stones in the illustration, feel pride in one of your accomplishments, whether big or small.

AFFIRMATIONS

Choose an affirmation and repeat several times daily, or during meditation:

1. I am proud of all my accomplishments.
2. Living each day with gratitude and happiness is an accomplishment.
3. I accomplish my goals with enthusiasm and ease.

THREE THINGS I HAVE ACCOMPLISHED

Make a list of things you are proud of, your accomplishments and achievements. *For example, completing school, learning to drive, raising children, exercising regularly.* Look to this list whenever you feel down.

1. ...
2. ...
3. ...

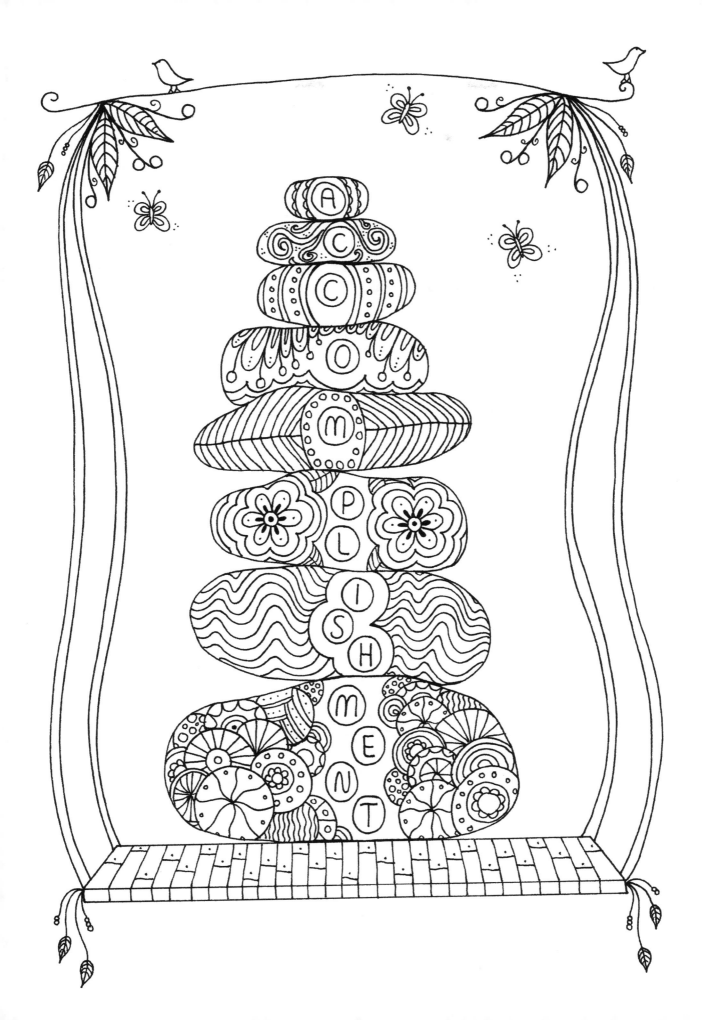

> "Life is too sweet and short to express our affection with just our thumbs. Touch is meant for more than a keyboard."
> ~ KRISTIN ARMSTRONG

COLORING TIP

As you color, recall happy moments of affection you have experienced in your life.

AFFIRMATION

Repeat this affirmation several times daily, or during meditation:

I am open to giving and receiving affection and embracing the power of human touch.

HUGGING MEDITATION

A simple hug can reduce stress, bring calm and comfort, and increase the sense of being supported and understood. The power of a hug is that you are giving and receiving at the same time.

Try this beautiful meditation with a willing participant. If there is no one around, you can even try it as a visualization—imagining someone you would like to give the gift of a meaningful hug to.

1. Stand in front of each other, smile, and make eye contact. Feel appreciation for this person in your life.
2. Slowly wrap your arms around each other.
3. Synchronize your breathing with the other person's.
4. Focus on the sensation of your body being in contact with theirs, and imagine warmth and love radiating from your hands to their body.
5. Stay in this relaxed and supportive hug for at least six slow breaths (one minute), or however long it feels right.

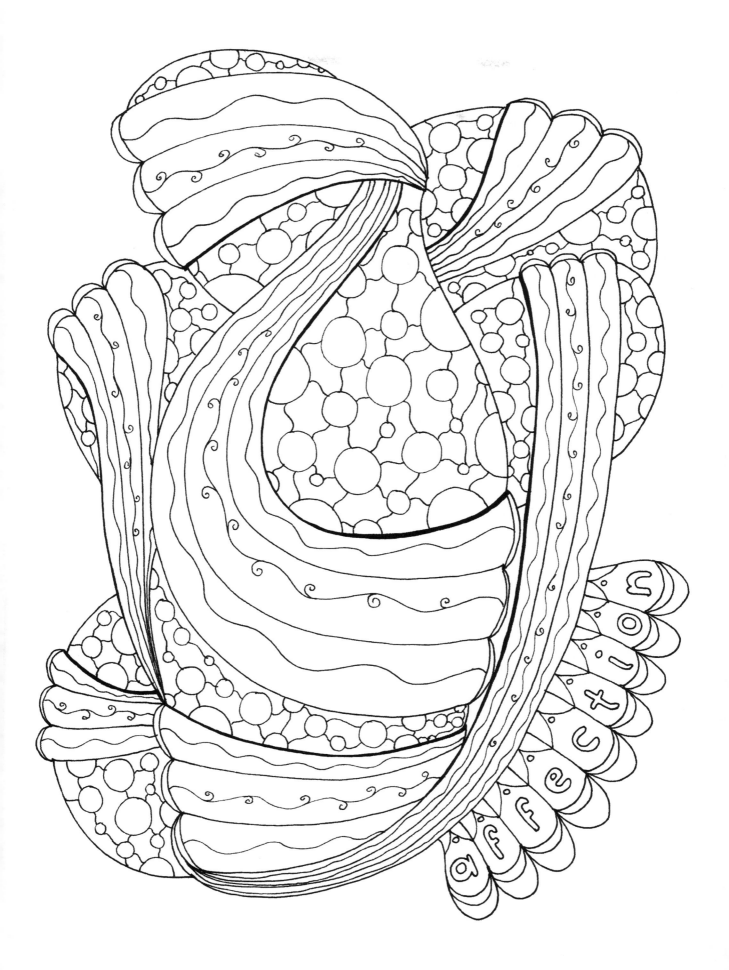

> "The goal of life is to make your heartbeat match the beat of the universe, to match your nature with Nature."
> ~ JOSEPH CAMPBELL

AFFIRMATIONS

Choose an affirmation and repeat several times daily, or during meditation:

1. My first priority is my own alignment. From that place of well-being, I am of more value to myself and others.
2. I love that the process of bringing about what I desire begins with the joy of alignment.
3. From my state of alignment, my dreams become reality.

THREE THINGS THAT MAKE ME FEEL GOOD

List things that help you feel good, and therefore help bring you back into alignment. *For example, taking the dog for a walk, floating in water, laughing, making a gratitude list.* Whenever you feel overwhelmed, sad, frustrated, or angry, do one of these things until you feel the relief of alignment return.

1. ..
2. ..
3. ..

Alignment is about getting in touch with your true self and focusing on what makes you feel good. Being in a state of alignment allows you to attract other people who have found their own alignment, and beneficial experiences that match your state of joy, making it more likely for things you desire to come into your life.

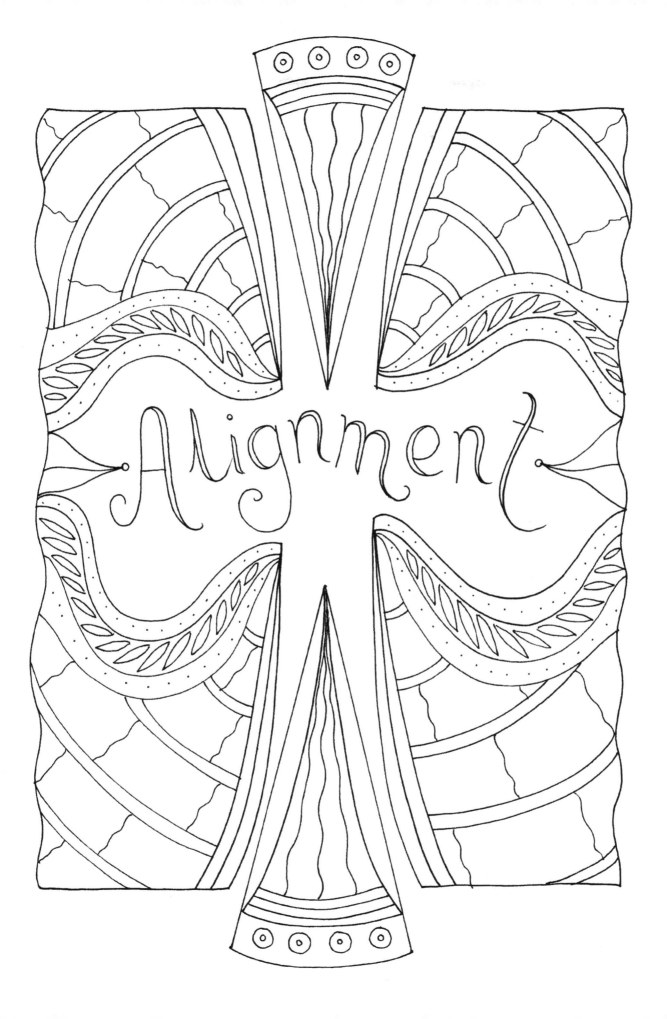

> "The roots of all goodness lie in the
> soil of appreciation for goodness."
> ~ DALAI LAMA

COLORING TIP

Allocate a color for each of the three things in your appreciation list, and as you color, allow that appreciation to fill your awareness.

AFFIRMATIONS

Choose an affirmation and repeat several times daily, or during meditation:

1. I make a conscious and genuine effort to show appreciation each day.
2. By focusing on what I appreciate in life, I manifest and experience more things to appreciate.
3. I appreciate my life, my body, and the world around me. Thank you.

THREE THINGS I APPRECIATE

List three things you appreciate. In addition, try writing an appreciation list each night before sleep. You can list general things you are appreciative of, or you can list things specific to the day that has just occurred. *For example, sunny weather, my affectionate cat, a tasty meal, my family, the air in my lungs.*

I APPRECIATE...

1. ..
2. ..
3. ..

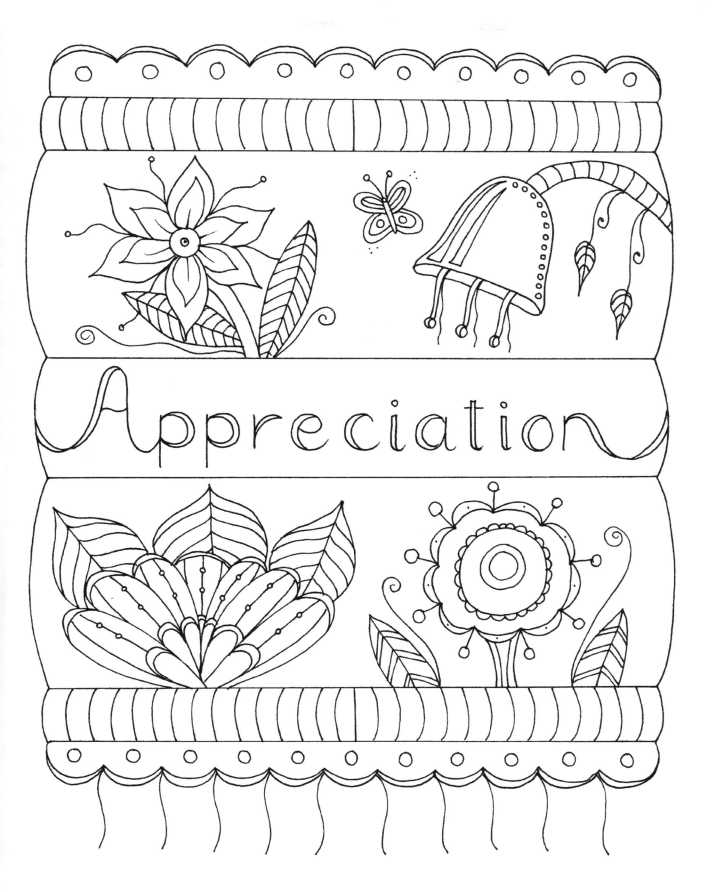

> "Plant the seed of desire in your mind and it forms a nucleus with power to attract to itself everything needed for its fulfillment."
> ~ ROBERT COLLIER

COLORING TIP

As you color, focus on something you would like to attract into your life, and feel the essence of it. What does it look like, how does it make you feel?

AFFIRMATIONS

Choose an affirmation and repeat several times daily, or during meditation:

1. Today I choose to attract positive experiences into my life.
2. I choose thoughts that make me feel good, attracting more feel-good things into my life.
3. I know that by being my authentic self I attract only things that are beneficial to the big picture of my life.

I WOULD LIKE TO ATTRACT...

Complete this sentence: If I woke up tomorrow with three new things in my life, I would like them to be... *For example, energy and health, a partner, a child, a new job.*

IF I WOKE UP TOMORROW WITH THREE NEW THINGS IN MY LIFE, I WOULD LIKE THEM TO BE...

1. ...
2. ...
3. ...

When you feel a lack of something, you are unlikely to attract what you are lacking. By feeling the essence of what you desire as though it is already in your life, you are more likely to attract it into your life. If you want more financial abundance, don't focus on your bills or dwindling bank account: focus on how great it was that you were able to buy food today, or that you bought coffee for a friend, enjoying the abundance already in your life.

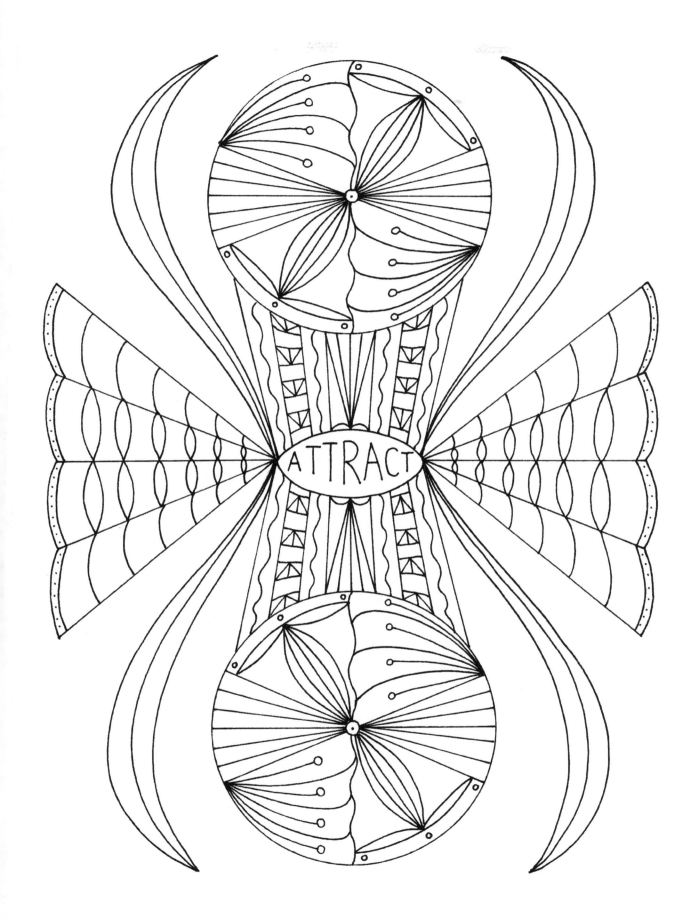

> "We need to find the courage to say no to the things and people that are not serving us if we want to rediscover ourselves and live our lives with authenticity."
> ~ BARBARA DE ANGELIS

COLORING TIP

As you color, think about what makes you unique, and celebrate those aspects of yourself.

AFFIRMATIONS

Choose an affirmation and repeat several times daily, or during meditation:

1. I fully embrace and accept my authenticity.
2. I embrace my individuality and live an authentic life.
3. I am safe to be who I am. By being me, my life becomes something magical.

MY AUTHENTIC SELF

Complete this sentence: When I am my authentic self, I am… *For example, helpful, funny, a good listener, honest and direct, colorfully dressed, observant.* Whatever makes you "you," not someone you're trying to be.

WHEN I AM MY AUTHENTIC SELF, I AM…

1. ..
2. ..
3. ..

By living and behaving authentically, you attract authentic people and situations that are in alignment with who you really are, making your life experiences more beneficial.

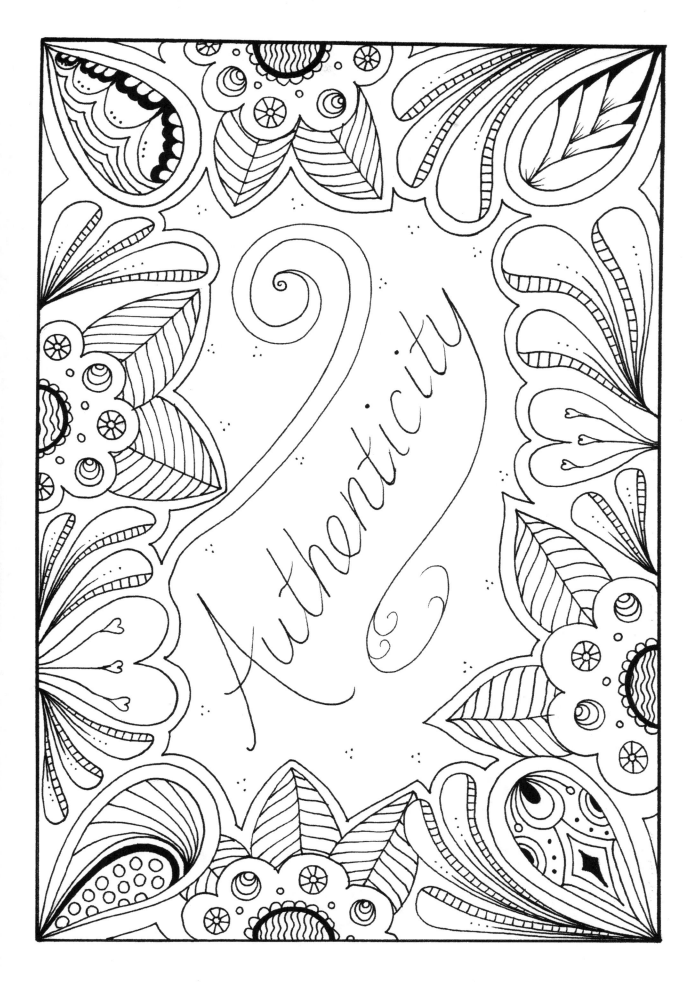

> "When we fall asleep, we withdraw
> our awareness from its hypnotic
> fascination with physical sensation,
> thereby enabling us to listen with
> our now awakening sixth sense."
> ~ HENRY REED

COLORING TIP

As you color, recall any moments in your life when you felt really alive, awake, and aware, as though life had been magnified. Some examples might be seeing your baby for the first time, winning something, or achieving a goal.

AFFIRMATION

Repeat this affirmation several times daily, or during meditation:

With the start of each new day and the passing of every hour, I feel an exciting sense of awakening to wonderful possibilities.

MORNING MINI MEDITATION

When you first wake up, take a few moments to awaken your senses. First, focus on what you can see. Notice shapes, colors, lines, patterns. Next, focus on what you can hear. Traffic, people, a fan, music or television or radio, your breath, or even silence. Now, what can you smell? Even if you can't smell anything, think of your favorite scent. Can you taste anything? What are you looking forward to tasting today? And touch, feel the sensation of your body on the bed, touch your skin, your clothing, your sheets. Give thanks for your senses and rise to greet the day. If any of your senses are impaired, give thanks for those senses that work well.

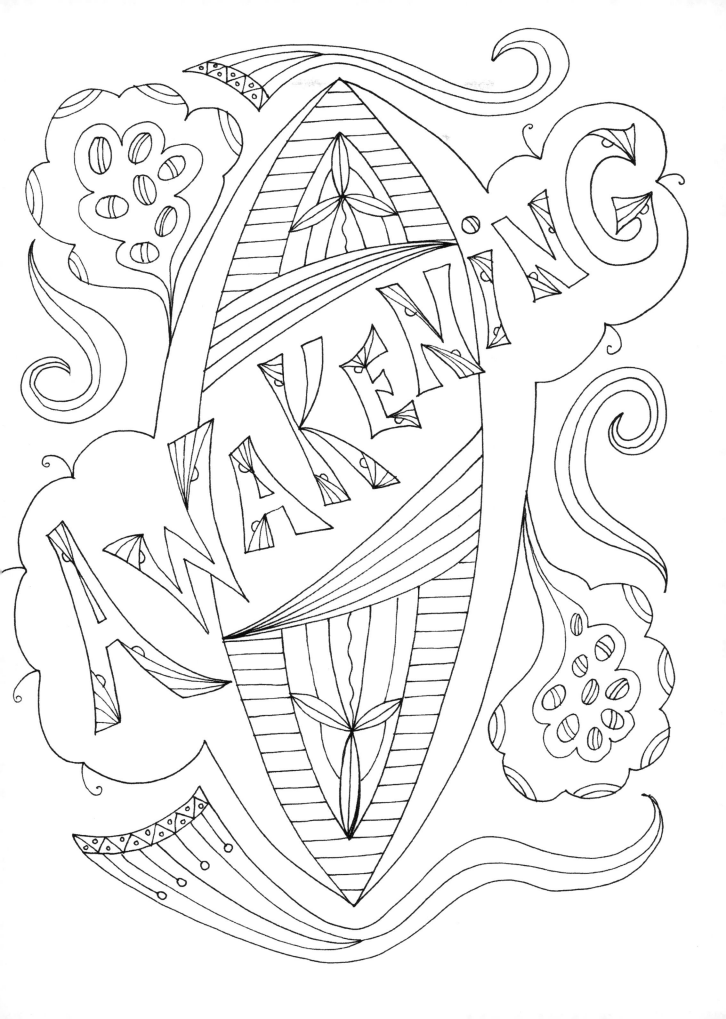

> "Let us not look back in anger,
> nor forward in fear, but
> around in awareness."
> ~ JAMES THURBER

AFFIRMATIONS

Choose an affirmation and repeat several times daily, or during meditation:

1. I replace worry with a calm awareness of each challenge, knowing that challenges are often opportunities in disguise.
2. I live my day with awareness, understanding, and acceptance.
3. I am always aware and responsive to my body's needs.

AWARENESS ACTIVITY

Right now, or sometime throughout your day, stop what you are doing for a few moments. Choose something to focus on and simply increase your awareness of it. It could be something still like an object, or something moving like cars outside your window, or leaves on a tree, or an animal. It could even be your breathing process. Focus on nothing but this for a few moments and feel the peace of being in the moment and appreciating the simplicity.

What you see or perceive is often only the tip of the iceberg. Just because something can't be seen doesn't mean it doesn't exist. Remember that there is always more beneath the surface, whether it be a person, a place, or an object. Do you know someone who is always getting irritated? Maybe they are not getting enough sleep, going through a difficult time, or just need someone to listen to them or remind them of their blessings. Replace judgment with awareness, and it will lead you to greater acceptance and understanding.

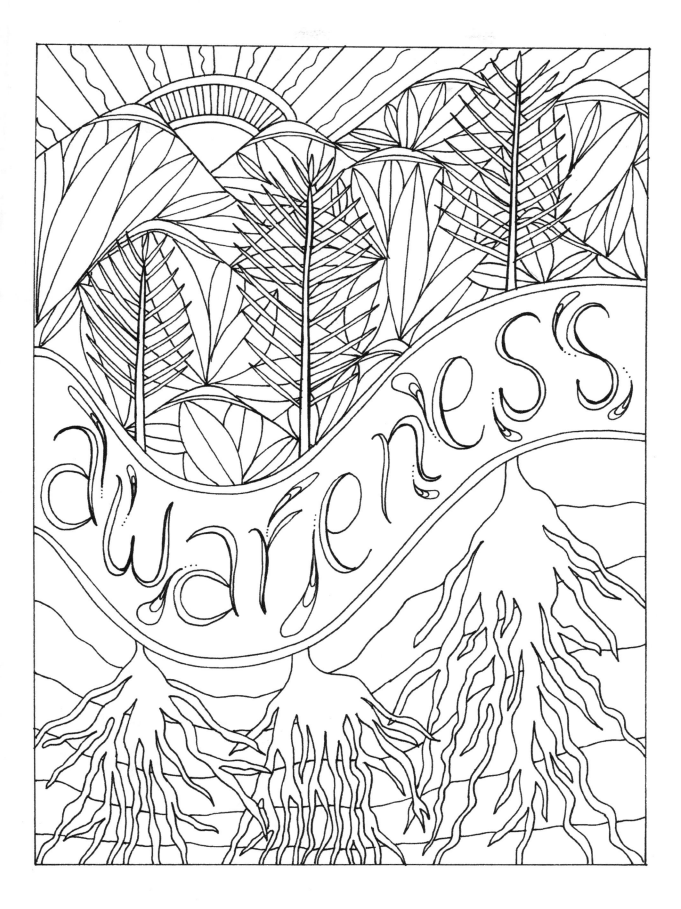

> "It is best to rise from life as from a banquet—neither thirsty nor drunken."
> ~ ARISTOTLE

AFFIRMATIONS

Choose an affirmation and repeat several times daily, or during meditation:

1. My body is working perfectly to maintain balance right now.
2. I choose to prioritize the things in life that are important to me.
3. I work with the harmony of nature to balance my mind, body, and lifestyle.

SELF-REFLECTION ACTIVITY

STEP 1: Think about how much time and energy you put into each life area.

STEP 2: Acknowledge where you are out of balance according to how much time and energy you'd rather spend on each. Are you not getting enough sleep? Are you spending time helping others but not yourself?

STEP 3: Note down any areas you would like to spend more (or less) time and energy on, and practical ways you could accomplish that.

1. Sleep
2. Relaxation, fun, and time for yourself
3. Work/study
4. Parenting/caring
5. Life maintenance (household shopping, cooking, cleaning, chores, commuting, paperwork, etc.)
6. Relationships (friends, family, partner)

Notice and appreciate evidence of balance in life…especially the balance of opposites like light and dark, stillness and movement, sun and rain, rest and activity, sound and quiet. The more you appreciate the evidence of balance, the easier it becomes to understand that no one thing is more important than another and that all things deserve their own time and space.

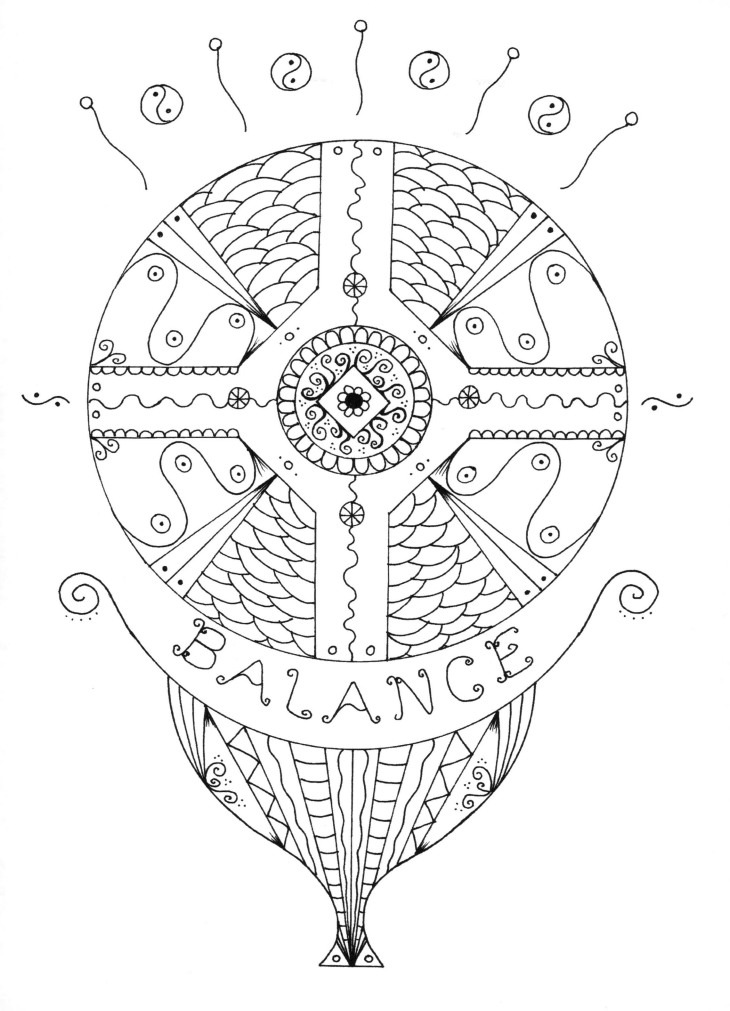

> "At some point in life the world's beauty becomes enough."
> ~ TONI MORRISON

COLORING TIP

As you color, think about something or someone and focus on all the aspects you find beautiful.

AFFIRMATIONS

Choose an affirmation and repeat several times daily, or during meditation:

1. I am surrounded by beauty and love.
2. I choose to see the beauty in everyone and everything.
3. My inner beauty shines through and radiates to the world around me.

MY BEAUTY

List three things about yourself that are beautiful. Even if you find this challenging, try to see the beauty in everything, knowing that you are an amazing creation with a purpose here on earth. You can list physical and/or non-physical aspects. *For example, my eyes, smile, hands, hair, my laugh, my generous nature.* Anything can be beautiful if you choose to see it that way.

1. ..
2. ..
3. ..

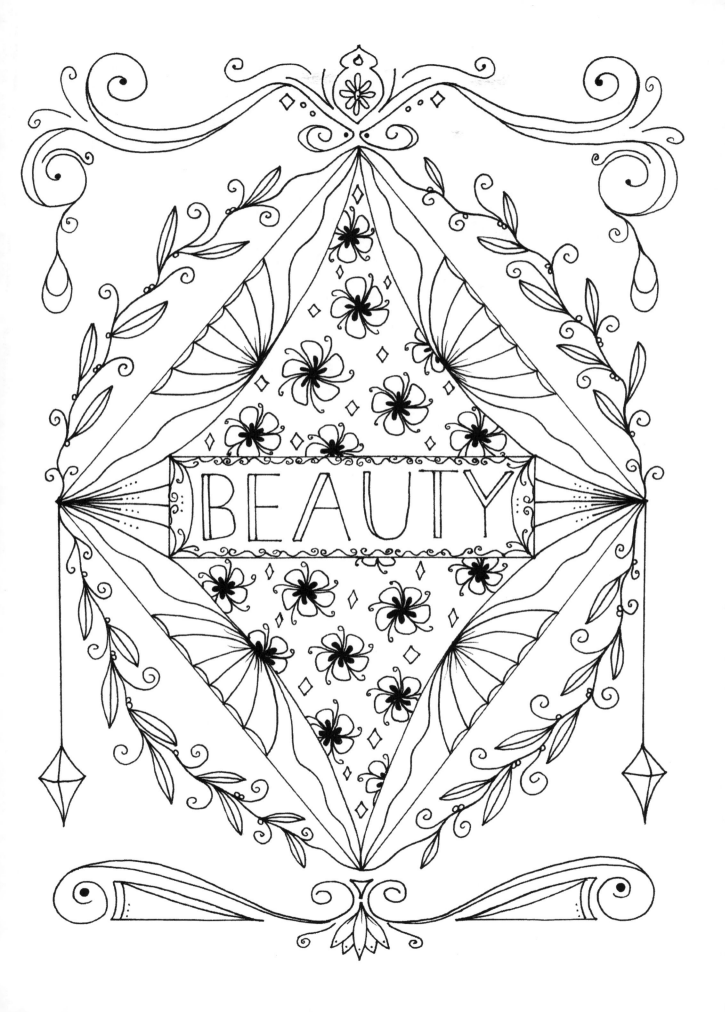

> "The journey of a thousand miles begins with a single step."
> ~ LAO TZU

COLORING TIP

When you start coloring, state this intention to yourself: "As I color this picture, I welcome and embrace a new beginning in my life and enjoy the journey that unfolds."

AFFIRMATIONS

Choose an affirmation and repeat several times daily, or during meditation:

1. I welcome a positive new beginning into my life right now.
2. I am excited and eager to make the most of this new day.
3. I release all past resentments and make way for joyful new experiences.

MY GOALS AND DESIRES

List three goals you would like to achieve and/or things you would like to experience or attract into your life. *For example, improve fitness, write a book, travel internationally, find a life partner.*

For each of your three goals or aspirations, write one small step you can take now to begin achieving your dreams. *For example, book a personal training session, sign up for a dating site, start a daily gratitude journal.*

1. ...
 ...
2. ...
 ...
3. ...
 ...

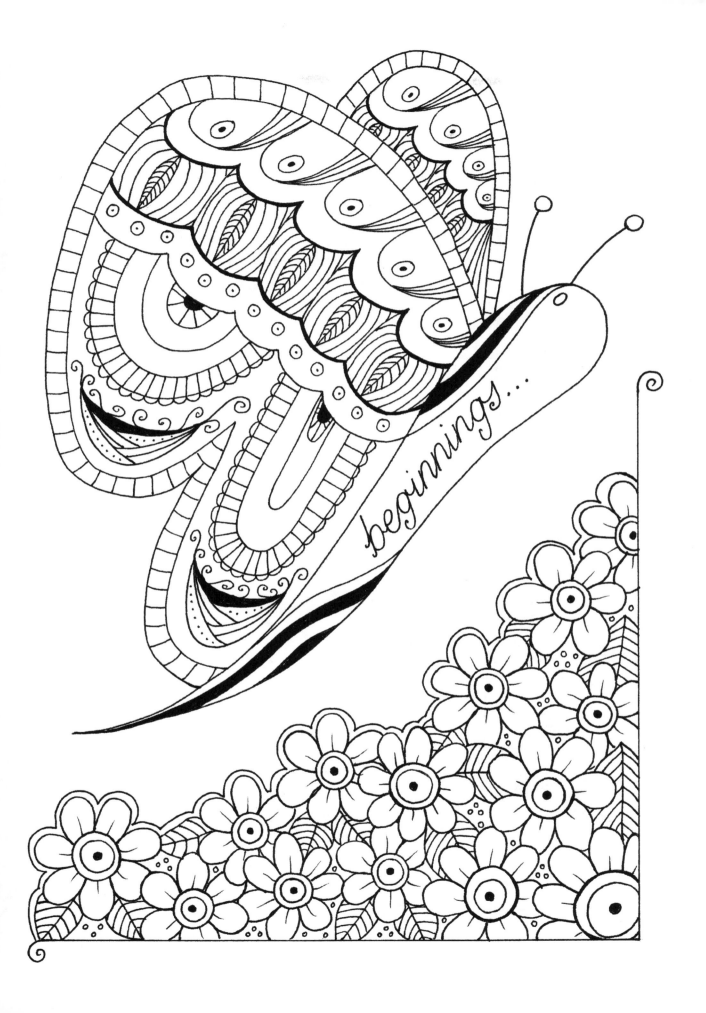

> *"Be where you are; otherwise
> you will miss your life."*
> ~ BUDDHA

COLORING TIP

Allocate one state of being for each letter of the word *being*, and as you color the illustration, focus on the feelings each state of being brings you.

AFFIRMATION

Repeat this affirmation several times daily, or during meditation:

I start each day with an awareness of what I choose to be, which naturally inspires what I choose to do.

A "TO BE" LIST

Try writing a "to be" list instead of a "to do" list. Often we get so caught up in being busy and doing things that we forget to embody a sense of "being." Examples of states of being include creative, helpful, generous, joyful, energetic, affectionate, inspiring.

I ENJOY BEING:

1. ..
2. ..
3. ..

> "To accomplish great things, we
> must not only act, but also dream;
> not only plan, but also believe."
> ~ ANATOLE FRANCE

AFFIRMATIONS

Choose an affirmation and repeat several times daily, or during meditation:

1. I believe that amazing things are possible.

2. I believe that everything is working out for me.

3. Belief lights my way toward my dreams. Believing is seeing.

Your beliefs shape your life experience. What you believe, you receive. If you believe you can never get a good parking spot, you'll most likely never get a good parking spot. Beliefs affect more significant things too. Beliefs such as "people always leave me" are based on prior experiences and insecurities, but they do not have to continue being true. You can take steps to overpower your limiting beliefs by consciously replacing them with new ones. These thoughts become habits, which create your new reality.

MY OLD BELIEFS

List three beliefs you feel are holding you back. *For example, people always leave me, money is evil.*

1. ..
2. ..
3. ..

MY NEW BELIEFS

Create new beliefs to replace the old ones. *For example, I am surrounded by supportive people, I support myself, money is a valuable tool to improve my life and help others.* When you find yourself thinking of the old belief, immediately replace it with your new belief.

1. ..
2. ..
3. ..

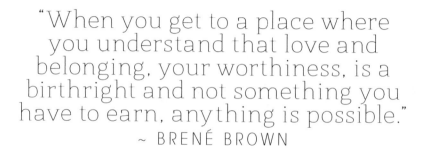

> "When you get to a place where you understand that love and belonging, your worthiness, is a birthright and not something you have to earn, anything is possible."
> ~ BRENÉ BROWN

AFFIRMATIONS

Choose an affirmation and repeat several times daily, or during meditation:

1. I am an important part of this world. I belong.

2. I feel connected to everything around me, and I'm filled with a sense of belonging.

3. I am accepted, understood, and part of a supportive circle of people where I truly belong.

BELONGING ACTIVITIES

Complete this sentence: I feel a deep sense of belonging when I... *For example, am around my family, meditate, arrive home at the end of the day, help a person in need.*

I FEEL A DEEP SENSE OF BELONGING WHEN I...

1. ..
2. ..
3. ..

Complete this sentence: I can help others feel they belong by... *For example, telling someone what they mean to me, thanking people for the impact they've had on my life, giving them credit for a job well done.*

I CAN HELP OTHERS FEEL THEY BELONG BY...

1. ..
2. ..
3. ..

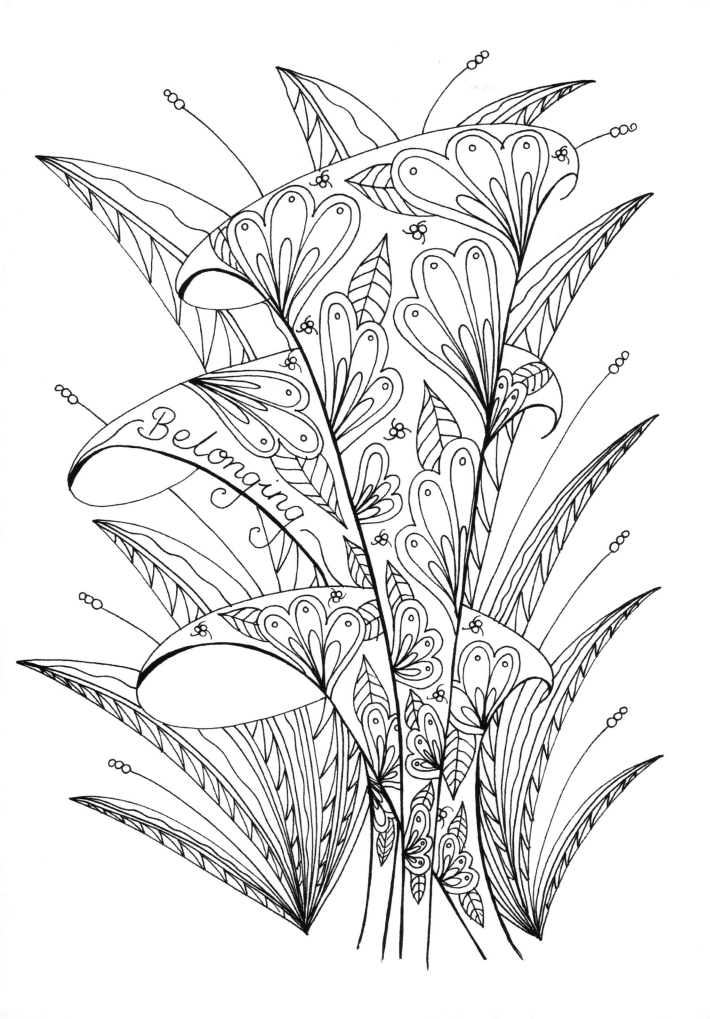

> "Follow your bliss and the universe will open doors where there were only walls."
> ~ JOSEPH CAMPBELL

COLORING TIP

Allocate a different color for various blissful activities, and dwell on the bliss they bring you as you color.

AFFIRMATIONS

Choose an affirmation and repeat several times daily, or during meditation:

1. I can summon a feeling of bliss whenever I choose.
2. I love the delicious, satisfying feeling of bliss when I do things I enjoy.
3. I choose to feel blissful today and every day.

MY BLISS LIST

List five things that make you feel blissful. Make an effort to do these things regularly. *For example, taking a bath, having a massage, being affectionate with my partner, playing with my pet, reading, drawing, dancing, swimming.*

1. ...
2. ...
3. ...
4. ...
5. ...

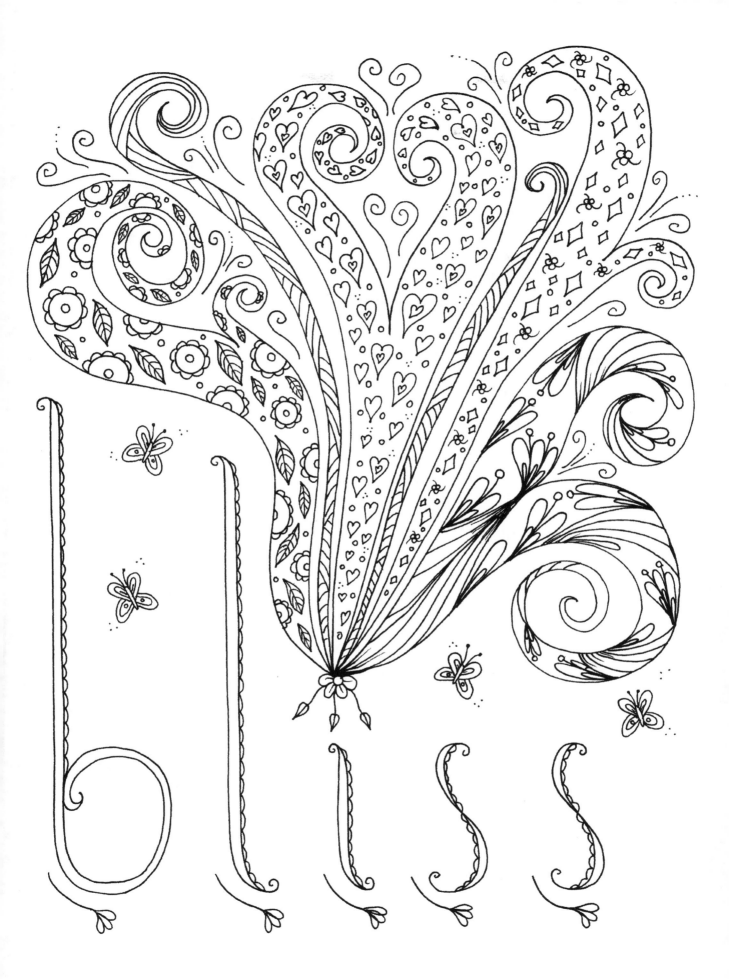

> "We must go beyond the constant clamor of ego, beyond the tools of logic and reason, to the still, calm place within us: the realm of the soul."
> ~ DEEPAK CHOPRA

COLORING TIP

Consciously color the illustration more slowly than normal. Feel the calm this brings. When you change colors, take three deep breaths.

AFFIRMATIONS

Choose an affirmation and repeat several times daily, or during meditation:

1. With my deep breath, I welcome a feeling of calm. All is well.
2. I am calm, clear, and confident.
3. As I breathe in and out, my mind and body become calmer.

MINI MEDITATION

Get comfortable and close your eyes. Listen to calming music or embrace the silence. Take ten deep breaths, and with each, imagine yourself sinking deeper into a state of calm relaxation. Imagine yourself in a calm, safe place. This could be lying in a hammock with the ocean breeze washing over you, snuggling up on a couch with a warm blanket, floating in water, or simply lying in bed under the covers. Focus on the sensations that make you feel calm: softness, warmth, coolness. Stay in this calm place for several minutes, then take three deep breaths, bring your awareness back to your body, and slowly open your eyes. Whenever you feel anxious, imagine your calm place.

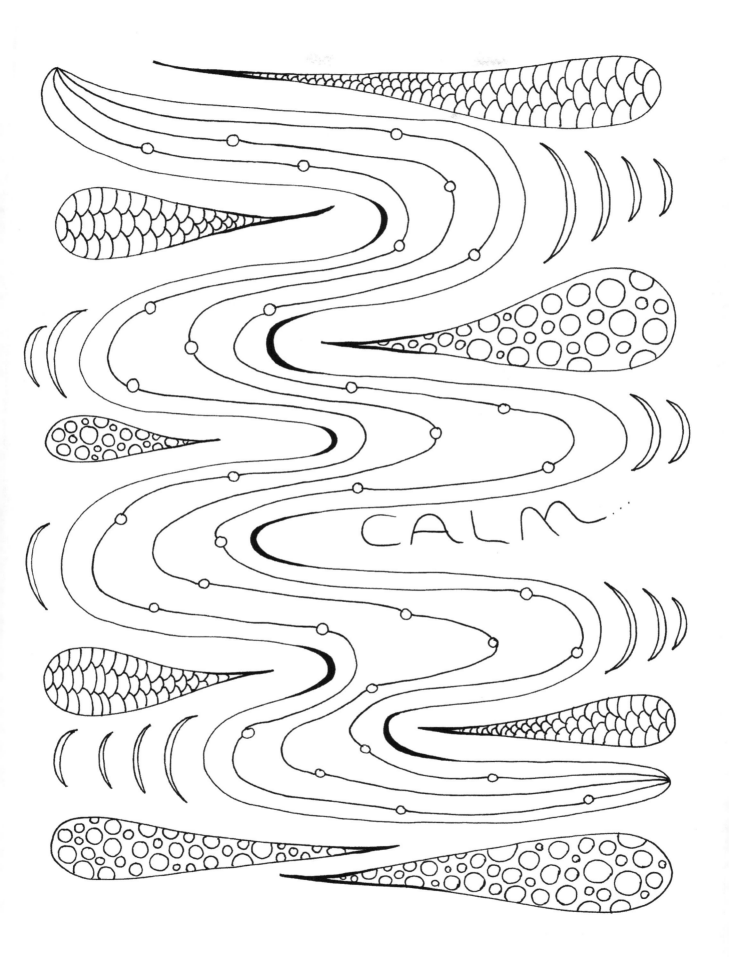

> "Cherish your visions and your dreams as they are the children of your soul, the blueprints of your ultimate achievements."
> ~ NAPOLEON HILL

COLORING TIP

As you color, think about the things in your life that you cherish, and give thanks for them.

AFFIRMATION

Repeat this affirmation several times daily, or during meditation:

I cherish myself and others, and I demonstrate this through respect, understanding, and love.

MINI MEDITATION

Close your eyes, and take several deep breaths. Think of someone or something you cherish. Imagine a supportive and loving light around them, in whatever color feels good to you. See this light protecting them, admiring them, cherishing them. See them happy and safe and loved. Now imagine this same light around yourself, connecting you to them. Feel thankful that you are cherished too. Open your eyes and take this feeling with you throughout your day.

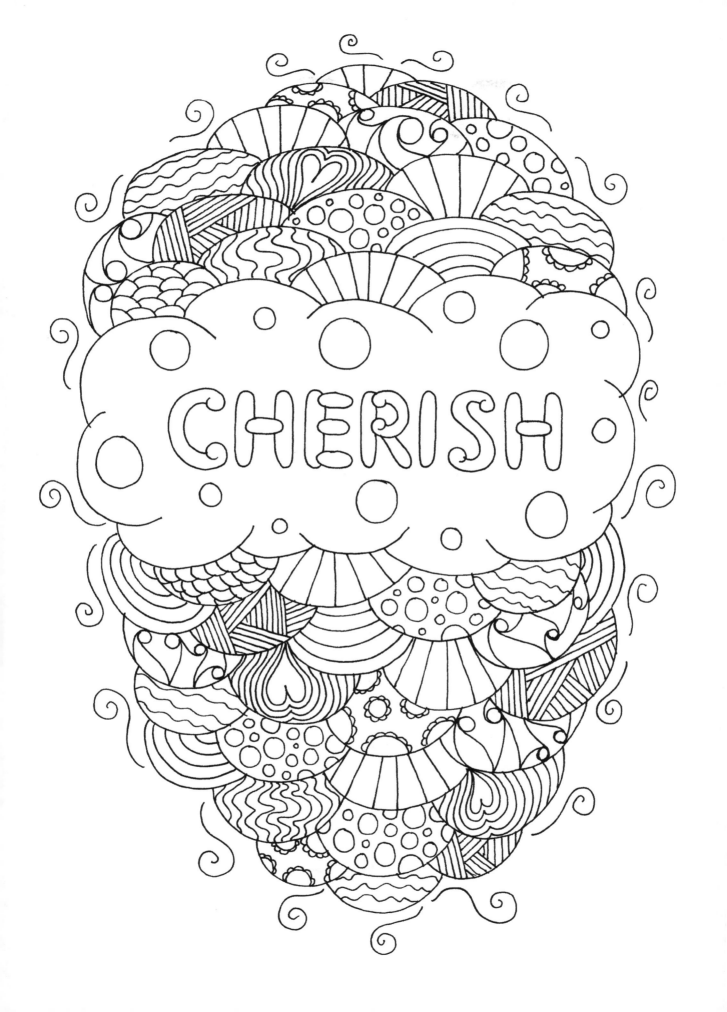

> "The only limit to your impact is your imagination and commitment."
> ~ TONY ROBBINS

AFFIRMATIONS

Choose an affirmation and repeat several times daily, or during meditation:

1. By making a commitment to myself, I attract people who demonstrate commitment to me also.

2. I honor and respect my commitment to myself in order to be the best me possible.

3. I know that through intention, enthusiasm, and commitment, I can achieve all my goals.

MY COMMITMENT TO MYSELF

Complete this sentence: From this moment on, I promise to commit to myself by doing the following: *For example, making good sleep a priority, celebrating my achievements and milestones, setting boundaries to honor the time I've set aside for myself.*

FROM THIS MOMENT ON, I PROMISE TO COMMIT TO MYSELF BY DOING THE FOLLOWING:

1. ..
2. ..
3. ..

Just as people sign written agreements for marriage or legal documents, you can make your own agreements to help you commit to certain things. Writing things down helps you see more clearly what is required and makes it more likely to be carried through. Try making brief commitment agreements for different goals, such as regular exercise: "Starting today, I commit to attending the gym three times a week on Mondays, Wednesdays, and Fridays." Sign your agreement and stick it somewhere you'll see it.

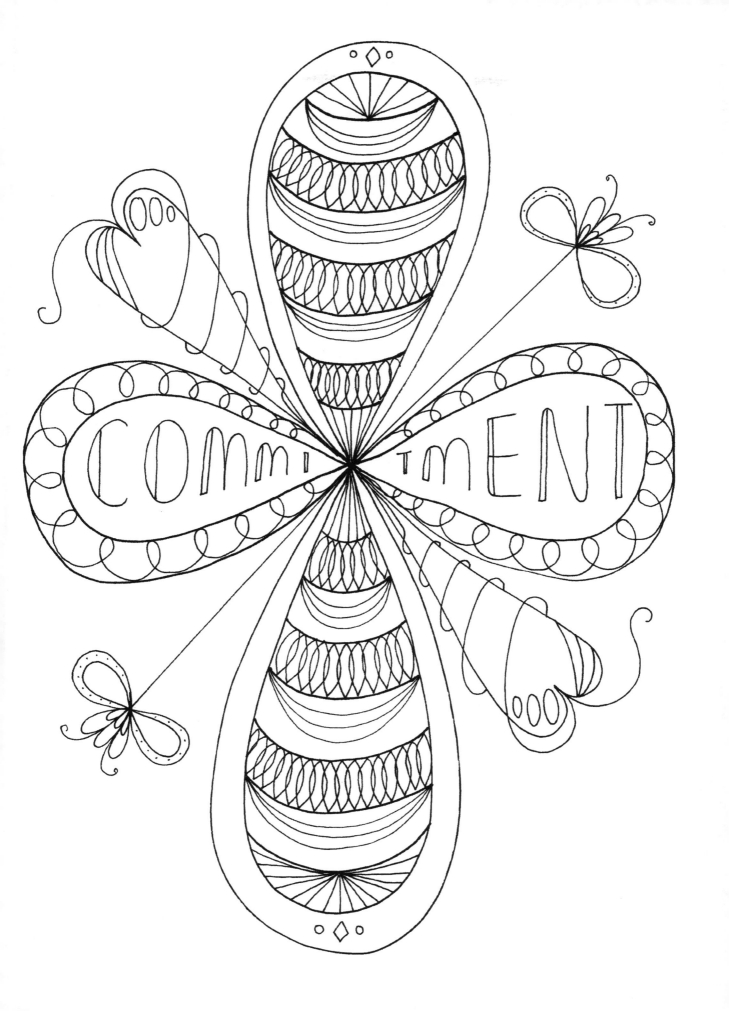

> "I turn to books for a feeling of companionship: for somebody knowing what I have known."
> ~ LOIS LOWRY

COLORING TIP

As you color, focus on those qualities you admire in a companion. Be on the lookout for people expressing these qualities as you start attracting more of what you are focused on.

AFFIRMATION

Repeat this affirmation several times daily, or during meditation:

I am a valuable companion to others, and I enjoy companionship in return.

COMPANIONSHIP QUALITIES

List three qualities that make you a good companion. *For example, good listener, understanding, inspiring, fun, helpful.*

1. ...
2. ...
3. ...

List three qualities you admire in companions.

1. ...
2. ...
3. ...

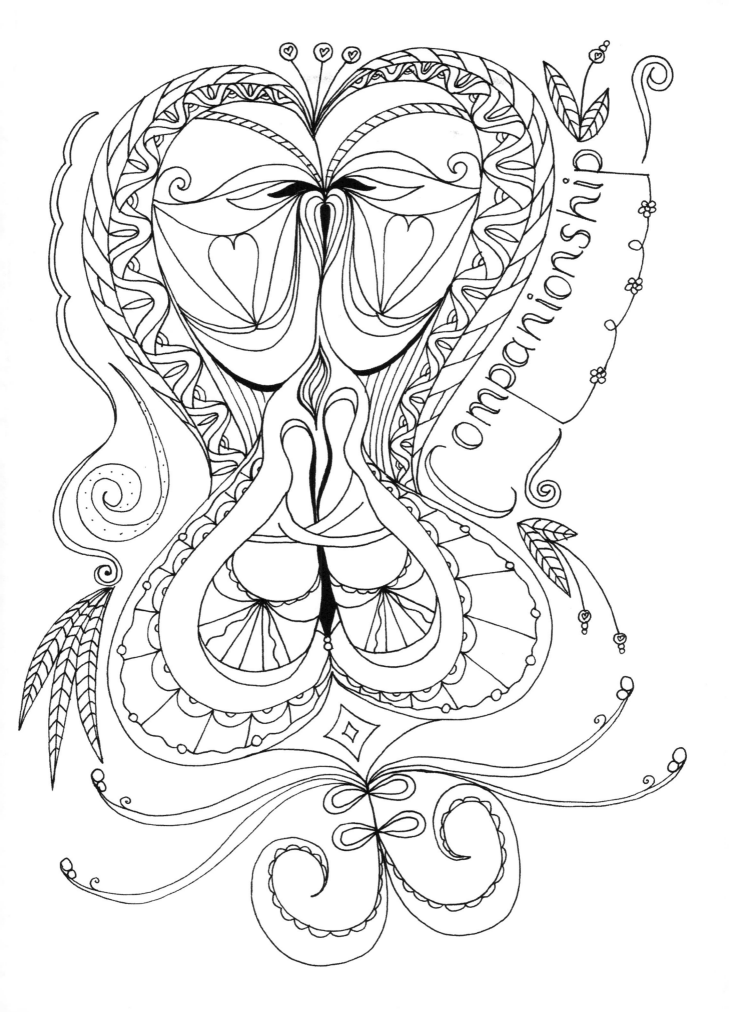

> *"The most beautiful thing you can wear is confidence."*
> ~ BLAKE LIVELY

AFFIRMATIONS

Choose an affirmation and repeat several times daily, or during meditation:

1. I am supported and encouraged in all my endeavors. Confidence is natural to me.
2. I am confident in my ability to do my best, and that is all I need to do.
3. The more I accept myself as I am, the more confident I become.

THREE TIPS TO PRACTICE SELF-CONFIDENCE

1. Talk to someone you've never spoken to before.
2. Sign up for a class in something you've always wanted to try.
3. When you're given a compliment, smile and say thank you instead of brushing it off.

MINI MEDITATION AND VISUALIZATION

Close your eyes and breathe deeply. Think of a time you felt really confident. What were you doing? How did it feel in your mind and body? Focus on those feelings. Now, take those feelings with you as you imagine something you would like to do or achieve, something that you feel you need more confidence for. See yourself achieving your goal with ease and confidence. Focus on how it will feel to do this, and as you return to your day, let the benefits you felt propel you forward to the next step with confidence.

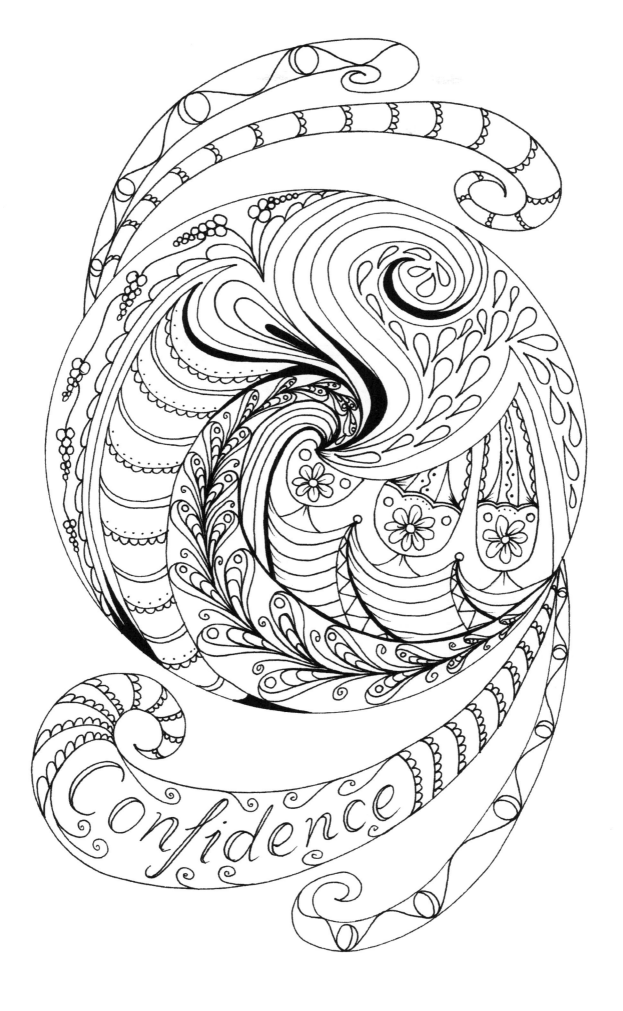

> "In nature we never see anything isolated, but everything in connection with something else which is before it, beside, it, under it, and over it."
> ~ JOHANN WOLFGANG VON GOETHE

COLORING TIP

As you color, focus your mind on a specific person (living or deceased), a favorite place, a pet, or nature. Feel your connection to them and imagine a two-way bond of peace and light between you.

AFFIRMATIONS

Choose an affirmation and repeat several times daily, or during meditation:

1. As I move through each day, I am in awe of the sense of connection I have with everyone and everything.

2. I am connected with all those I love, even if they are not physically present.

3. As I breathe deeply, I bask in the loving connection I feel with my soul.

TIMES I'VE FELT CONNECTED

List times in your life when you've felt a deep sense of connection to another person, place, or thing. *For example, when you met your partner, saw your first child, walked through a beautiful environment.*

1. ...
2. ...
3. ...

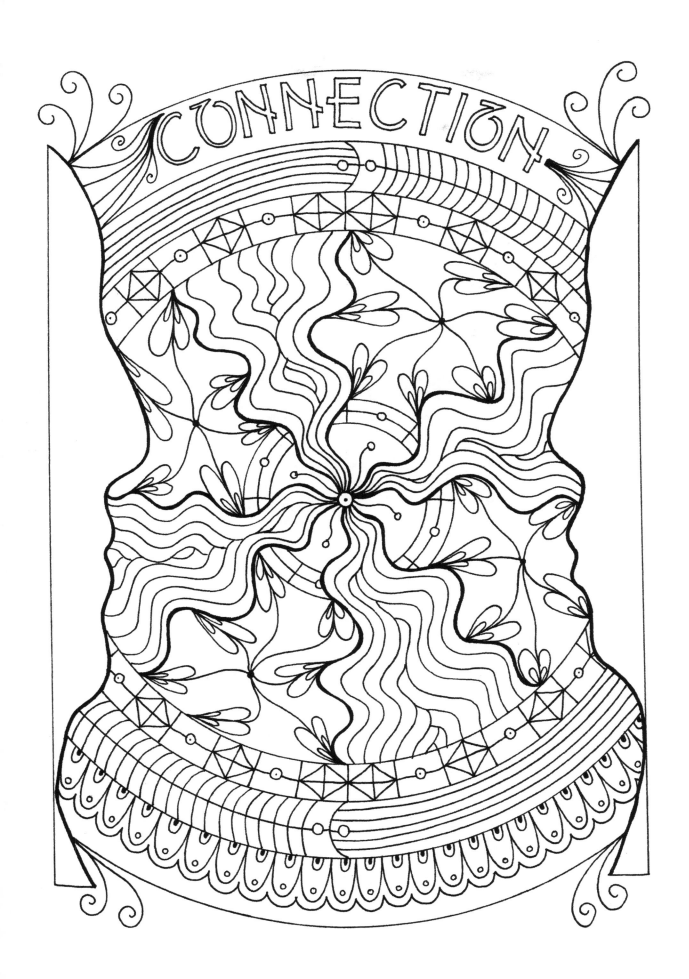

> "Courage is what it takes to stand
> up and speak; courage is also what
> it takes to sit down and listen."
> ~ WINSTON CHURCHILL

AFFIRMATIONS

Choose an affirmation and repeat several times daily, or during meditation:

1. My courage is stronger than my fear. I can do this.

2. I am confident, calm, and courageous.

3. Amazing opportunities and possibilities greet me when I show courage.

THREE WAYS I'VE BEEN COURAGEOUS

List times in your life when you've shown courage by doing something beyond your comfort zone or standing up for yourself or another.

1. ..
2. ..
3. ..

The benefits of being courageous usually far outweigh the fear of doing something beyond our comfort zone. Think about how important something is to you and imagine how you will feel if you don't do it, or if you don't take a chance. Can you live with that? If the thought of having done it feels better than the thought of not having done it, then you know what you have to do. Be courageous. Go for it!

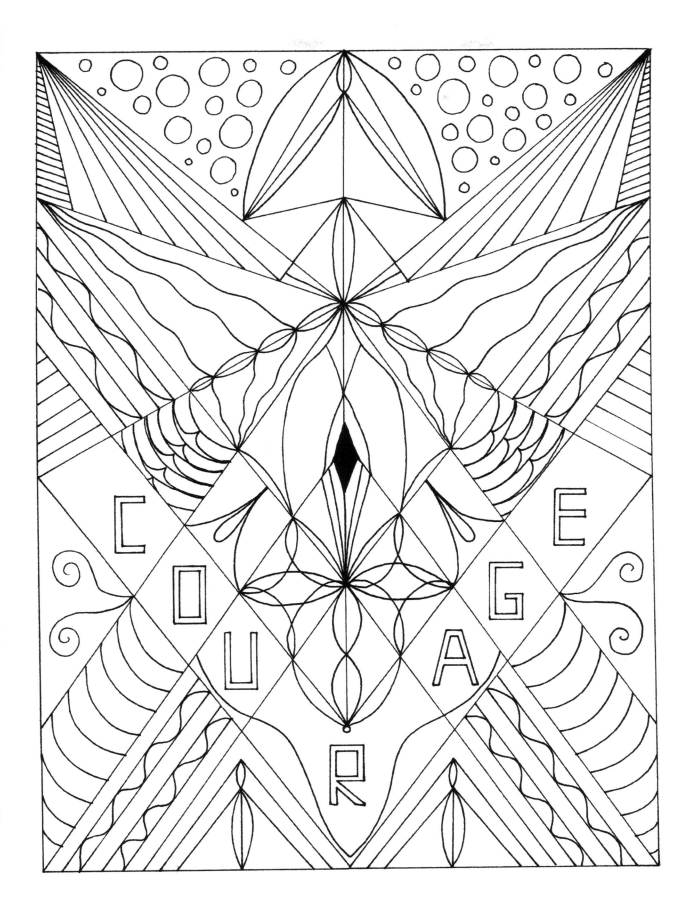

> "Creativity is just connecting things. When you ask creative people how they did something, they feel a little guilty because they didn't really do it, they just saw something. It seemed obvious to them after a while. That's because they were able to connect experiences they've had and synthesize new things."
> ~ STEVE JOBS

COLORING TIP

As you color, keep repeating one of the affirmations. Choose colors based on natural creative instinct rather than planning it out.

AFFIRMATIONS

Choose an affirmation and repeat several times daily, or during meditation:

1. I let my natural creativity run free without judgment.
2. The more I indulge my creativity, the more creative I become.
3. Creative solutions and ideas come to me frequently and at perfect times.

CREATIVE THINGS I ENJOY

List activities you enjoy doing that embody creativity. *For example, coloring, making things, creating new recipes, designing clothing, garden landscaping.*

1. ...
2. ...
3. ...

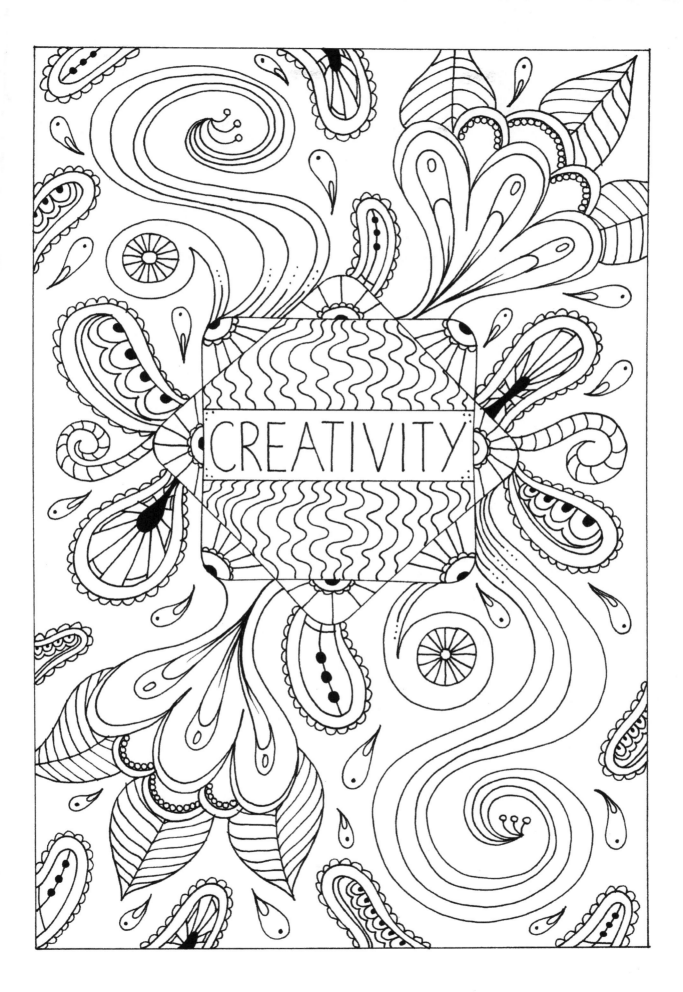

"When you dance, your purpose is not
to get to a certain place on the floor.
It's to enjoy each step along the way."
~ DR. WAYNE W. DYER

COLORING TIP

Listen to your favorite music to dance to as you color the illustration.

AFFIRMATION

Repeat this affirmation several times daily, or during meditation:

The beauty of my heart and soul shines bright when I move my body through dance.

DANCE CHALLENGE

When was the last time you let yourself move to the rhythm of music? Whether you're a confident dancer, have two left feet, or are physically unable to dance, you can enjoy the healing power of dance in whatever way is suitable for you. You can do something as simple as listen to music and imagine yourself dancing in your mind, or you can turn the music up at home and let loose. Allow yourself to enjoy the fun of movement. If you feel inspired, sign up for a dance class, or if you already dance, try a new dance style.

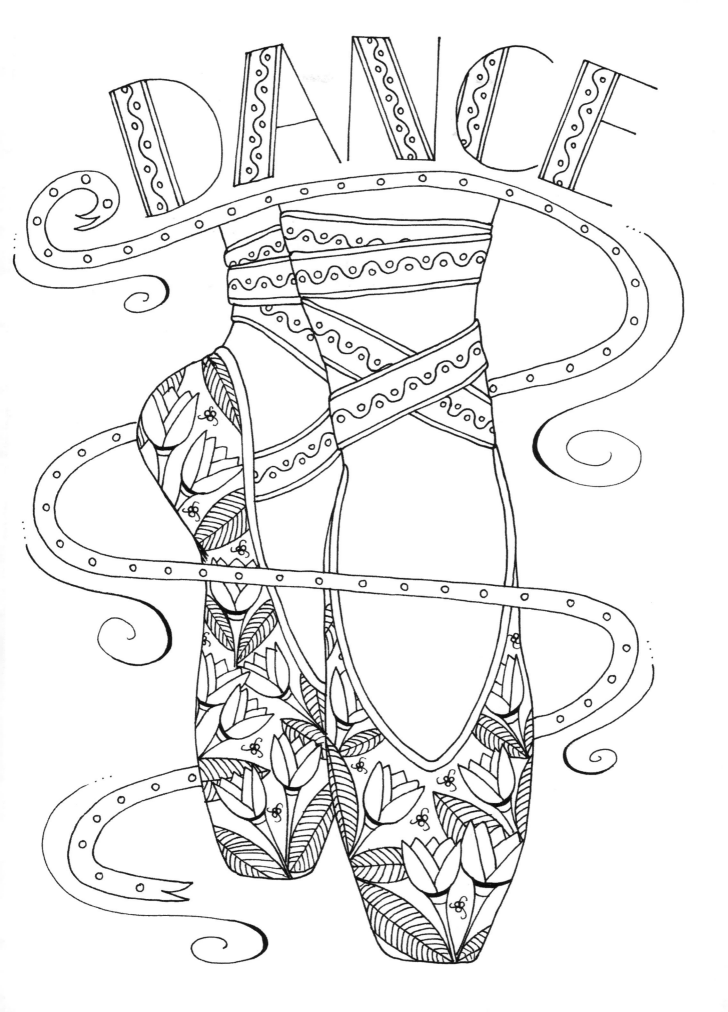

"Our history is not our destiny."
~ ALAN COHEN

COLORING TIP
Start from the bottom and work your way up. When you reach the circles, get a feeling for how you want the big picture of your life to be. Feel the satisfaction from a life well lived.

AFFIRMATIONS

Choose an affirmation and repeat several times daily, or during meditation:

1. I can create my own destiny through consciously harnessing the law of attraction.
2. I trust that my destiny is unfolding exactly as it should.
3. I live a life aligned with my true purpose and destiny.

MINI MEDITATION

Get into a comfortable position either seated or lying down. Close your eyes and take several deep breaths. When you feel relaxed, imagine yourself taking ten slow steps up a staircase. With each step you feel lighter and happier. When you get to the tenth step, you are completely living your destiny. What does it feel like? What are you doing? Who are you with? Don't think too hard about it, just allow images and feelings to come to you naturally. Bask in the joy of your life, and when you're ready, open your eyes.

Living our destiny is a combination of creating our own reality and allowing the natural flow of life to unfold; a synergistic blend of two life forces—that of the universe, and our own free will and choices.

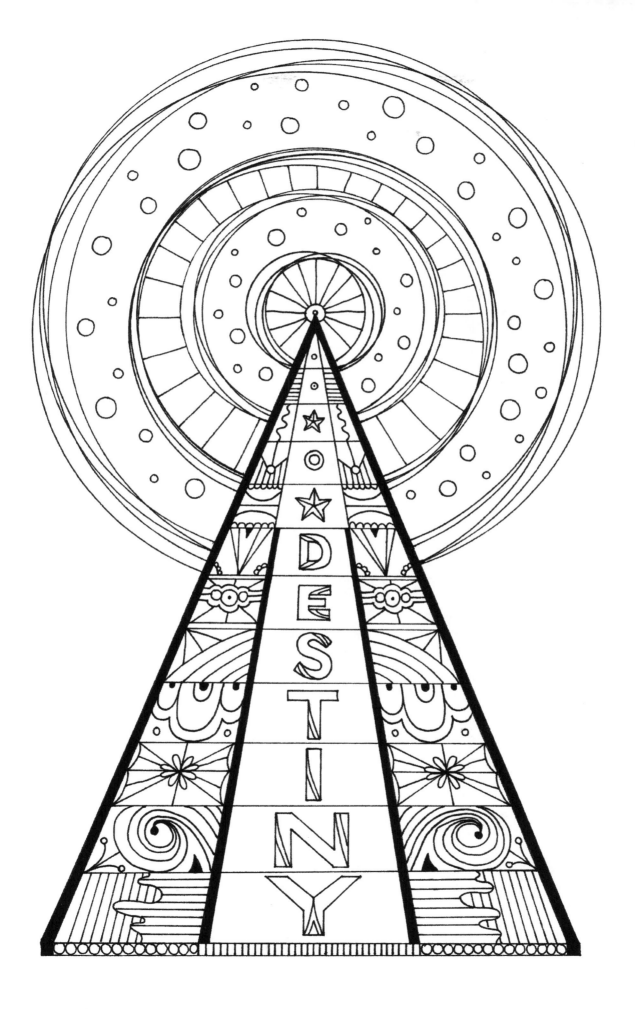

> "The only true voyage of discovery,
> the only fountain of Eternal Youth,
> would be not to visit strange lands
> but to possess other eyes."
> ~ MARCEL PROUST

AFFIRMATIONS

Choose an affirmation and repeat several times daily, or during meditation:

1. I am eager and excited to discover new people, places, and experiences each day.

2. Discovering the world starts with discovering myself. I listen and learn from my inner guidance.

3. I intend to discover something amazing today.

THREE TIPS FOR DISCOVERING MORE ABOUT LIFE

1. Read more books, both fiction and nonfiction.

2. Be open to new experiences to expand your horizons.

3. Ask someone for their life story in a nutshell.

THREE THINGS I WOULD LIKE TO DISCOVER

List what you would like to discover in life, whether it be a place you've never been, history you'd like to understand, a scientific concept, or a personal life story from a relative or friend.

1. ...

2. ...

3. ...

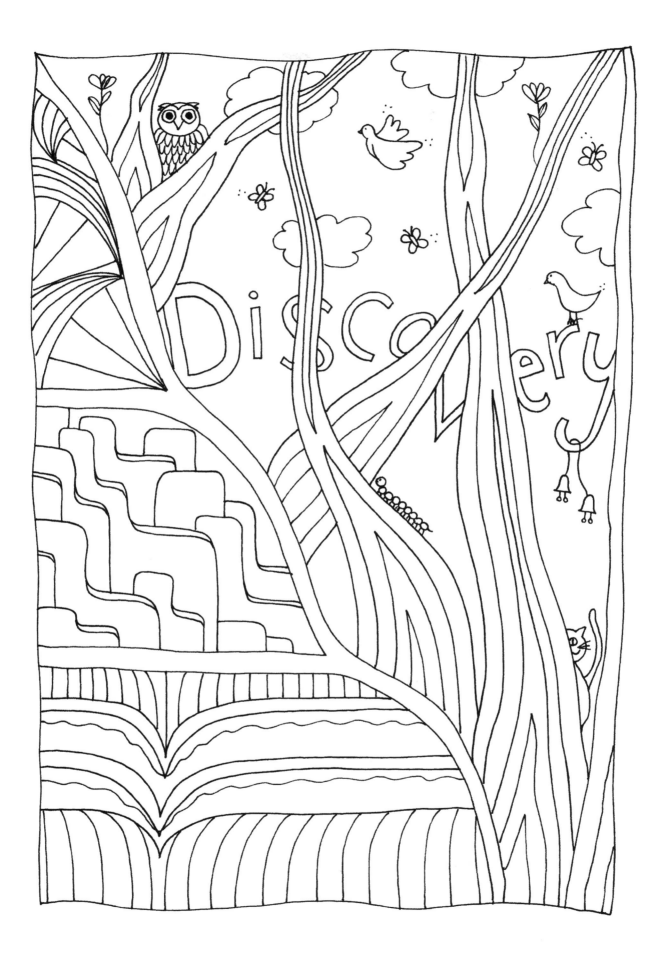

> "You are never too old to set another goal or to dream a new dream."
> ~ C.S. LEWIS

COLORING TIP

As you color, imagine yourself living the things on your Dream List and enjoy how it feels. You may like to give each of your dreams a specific color.

AFFIRMATIONS

Choose an affirmation and repeat several times daily, or during meditation:

1. I would not have a dream without the power to make it come true.
2. My dreams are valid, and I choose to follow my heart.
3. My dreams are limitless possibilities that are waiting for me to follow them.

MY DREAM LIST

Instead of a bucket list, create a Dream List. If you could do anything, go anywhere, achieve anything, what would you do? Write a list of things you would love to experience in your lifetime. Some may be things you can do very soon, others may be dreams that you aren't sure are even possible, but write them down anyway.

1. ...
2. ...
3. ...
4. ...
5. ...

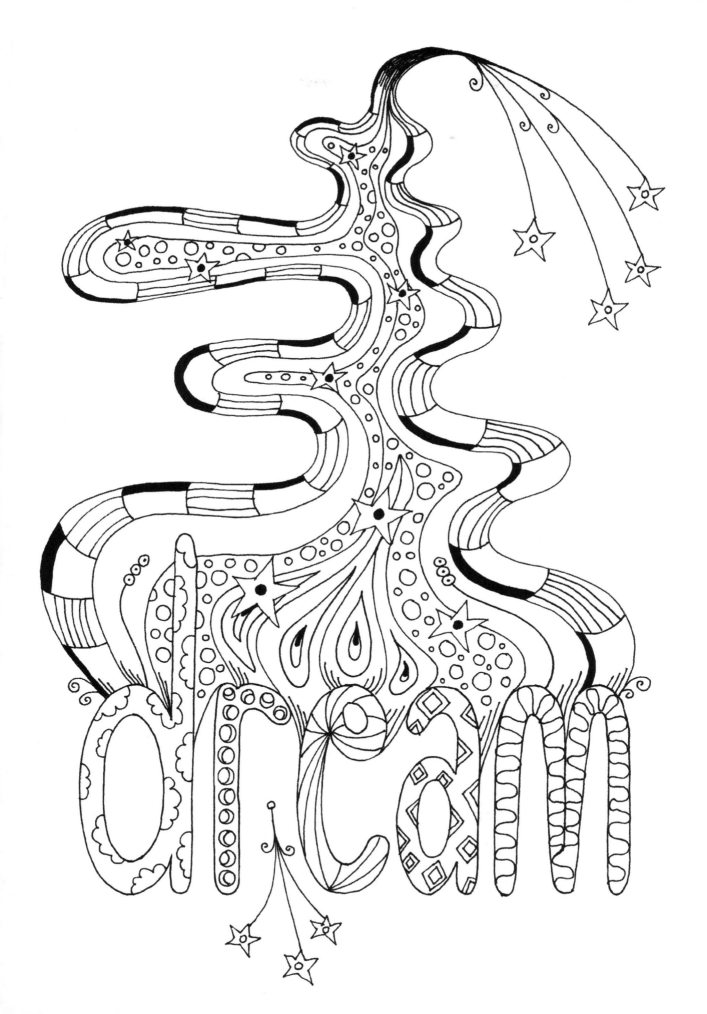

> "The process of spotting fear and
> refusing to obey it is the source
> of all true empowerment."
> ~ MARTHA BECK

AFFIRMATION

Repeat this affirmation several times daily, or during meditation:

I am empowered and capable in all that I do.

THREE TIPS FOR SELF-EMPOWERMENT

1. Listen to your gut instinct; follow your intuition and trust it.
2. Make decisions that feel right for you, then make them work.
3. Avoid putting yourself down, even with little things. Use positive self talk.

When we feel scared or uncertain, it's usually due to the feeling of losing control or our sense of self-empowerment. When we feel empowered we feel confident and supported and capable, and able to handle anything that comes our way. No matter what happens, whether you receive troubling news, or are going through a difficult time, always remember that self-empowerment is your right and is attainable when you tune into your inner self. Remember that you are stronger than you think.

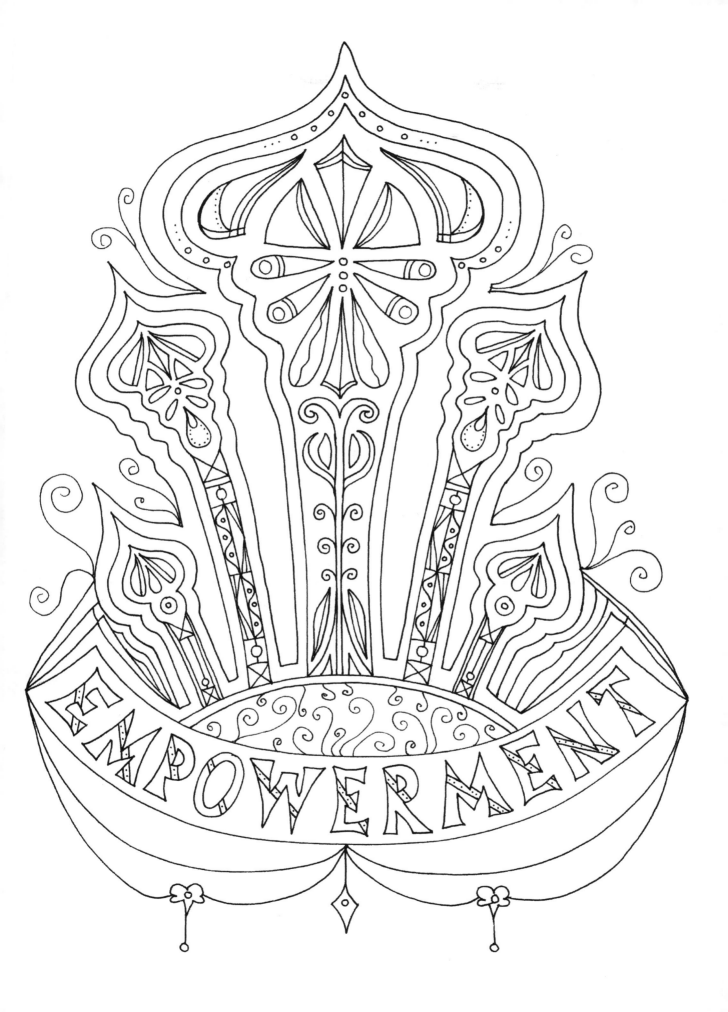

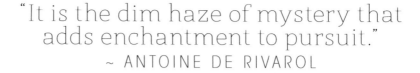

> "It is the dim haze of mystery that
> adds enchantment to pursuit."
> ~ ANTOINE DE RIVAROL

COLORING TIP

As you color, keep repeating one of the affirmations and dwell on the feeling of enchantment.

AFFIRMATIONS

Choose an affirmation and repeat several times daily, or during meditation:

1. I am enchanted with the magic of life.
2. I regularly experience magical moments of enchantment.
3. I see the enchanting beauty of people, places, and animals that I come across.

IF I HAD A MAGIC WAND...

When looking for solutions or answers, say to yourself, "If I had a magic wand..." You'd be surprised how much clearer you get about what you actually want and how you want things to change. This exercise may lead to creative solutions or ideas and may help you take the next best step in a situation. Think of a situation in particular, or your life overall, and complete the sentence:

IF I HAD A MAGIC WAND...

1. ...
2. ...
3. ...

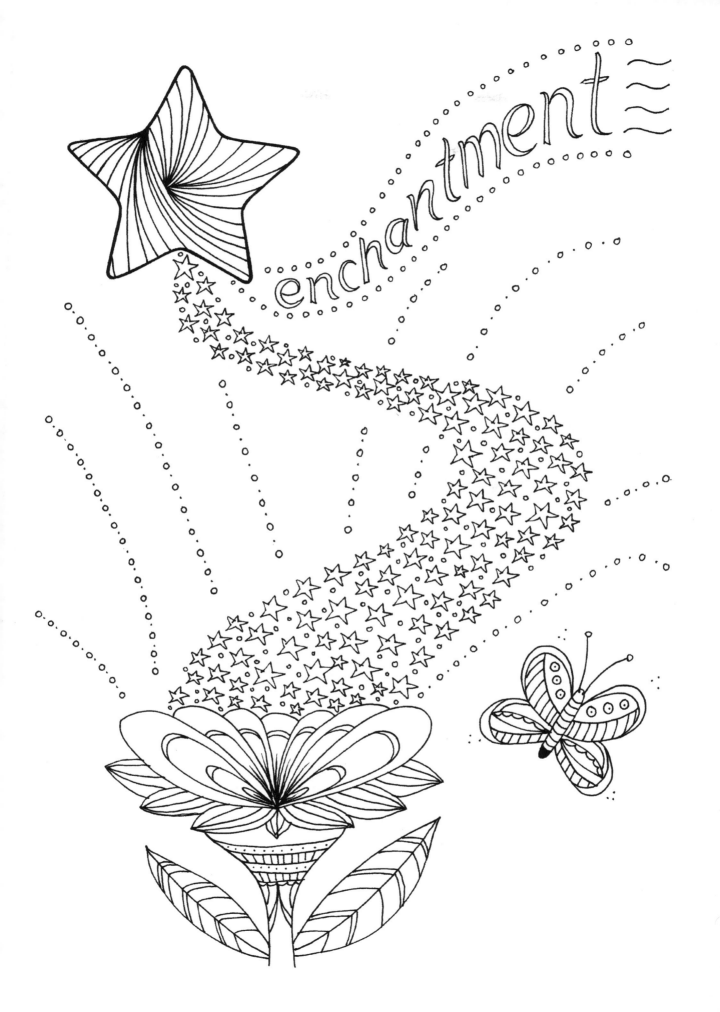

> "Knowing others is wisdom, knowing
> yourself is Enlightenment."
> ~ LAO TZU

AFFIRMATION

Repeat this affirmation several times daily, or during meditation:

Through a calm sense of wonder and awe, I receive enlightened knowledge, understanding, and awareness.

THREE TIPS TO ENHANCE ENLIGHTENMENT

Enlightenment can mean different things depending on your perspective and religious beliefs. What unites all perceptions is the idea of awakening or discovering ultimate truth. For the purpose of this activity page we will refer to enlightenment as becoming aware of a definite truth, a clear knowing and understanding of something. If you have differing beliefs you might choose to focus on them as you color, but if the following resonates with you, take action on the tips.

1. Learn to understand your dreams. Dreams can tell us much about ourselves and lead to greater awareness of truth from a nonphysical perspective. Keep a dream journal and look into dream interpretations, as well as the significance of your recurring dreams.

2. Learn to differentiate between an emotional, fear-based response based on prior experience, and a logical, appropriate response based on the evidence and your inner guidance.

3. Start a practice of yoga and meditation. When you blend mind-based activities with physical movement, you can become more aware of your body's messages, and your own intuition and truth.

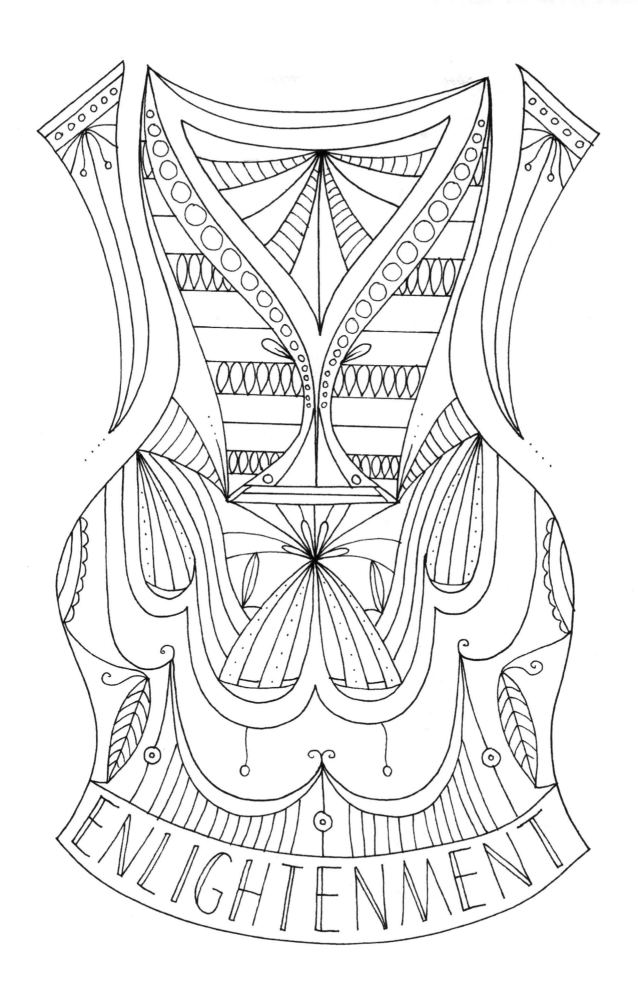

> "Faith is to believe what you do
> not see; the reward of this faith
> is to see what you believe."
> ~ SAINT AUGUSTINE

COLORING TIP

As you color, repeat your faith list from below out loud or in your mind.

Show you have faith by trusting your own decisions, taking a few risks, and showing faith in others. Let people know that you trust their judgment. Demonstrating faith leads you closer to your dreams.

AFFIRMATIONS

Choose an affirmation and repeat several times daily, or during meditation:

1. With faith, anything and everything is possible.
2. I have faith that the best possible outcome will unfold.
3. I am willing to take a leap of faith.

MY FAITH LIST

Write a list to demonstrate your embodiment of faith. *For example, my health will improve, I will find the right home, I can find the relationship of my dreams.*

I HAVE FAITH THAT...

1. ...
2. ...
3. ...

"I equate ego with trying to figure everything out instead of going with the flow. That closes your heart and your mind to the person or situation that's right in front of you, and you miss so much."
~ PEMA CHÖDRÖN

COLORING TIP

As you color, try synchronizing your coloring with your breathing, coloring a section with each exhalation to make it more meditative and flowing.

AFFIRMATIONS

Choose an affirmation and repeat several times daily, or during meditation:

1. Today I am going with the flow and enjoying the natural progression of the day.
2. By consciously living in the moment, life flows effortlessly and easily from one moment to the next.
3. I am attuned to the natural rhythm and flow of life.

MINI MEDITATION

Get comfortable and close your eyes. Take several deep breaths, feeling the air flow easily in and out of your lungs. As your body relaxes, imagine a flow of well-being entering your body through your lungs and reaching every cell in your body. With each exhalation imagine this flow swirling and flowing within your cells, nourishing them.

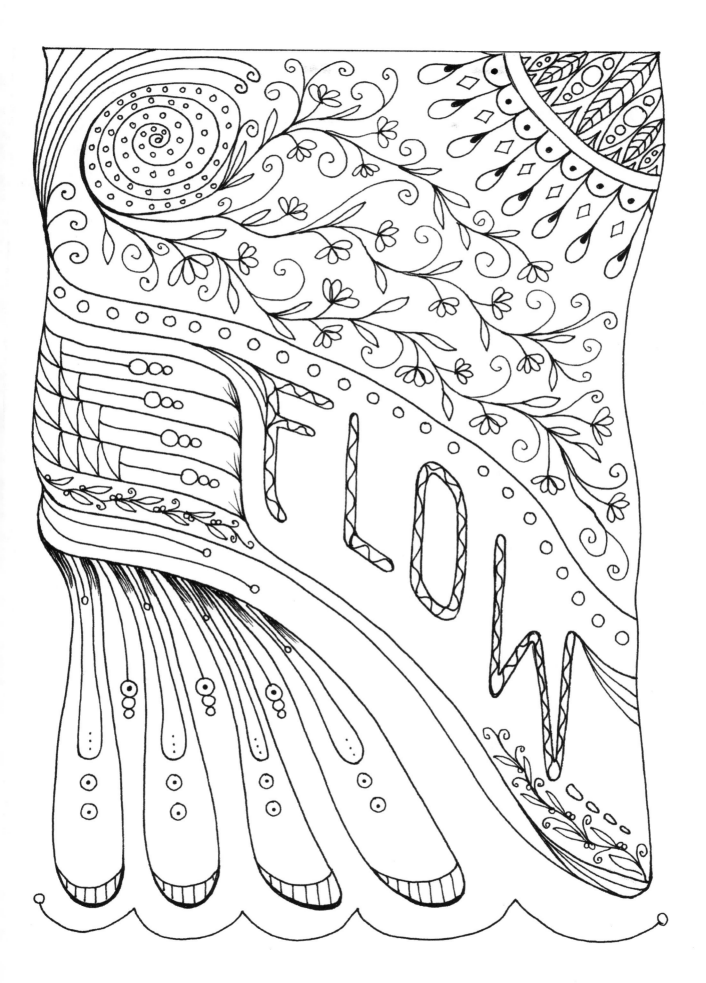

> "Focus on the journey, not the destination. Joy is found not in finishing an activity but in doing it."
> ~ GREG ANDERSON

COLORING TIP

Before you color, train your mind to focus by looking deeply at the illustration for a few minutes without doing anything. Just observe and see where your eye is naturally drawn.

AFFIRMATIONS

Choose an affirmation and repeat several times daily, or during meditation:

1. I choose to be more productive today by focusing on one thing at a time.
2. With conscious intention I can focus on things that make me feel good.
3. In this moment, I choose to focus on [add your object or task here].

THREE TIPS TO ENHANCE FOCUS

1. Keep hydrated by drinking plenty of water. Even minor dehydration can reduce concentration and focus.
2. Take regular breaks both for the mind and body. Stretch, look into the distance, take a few deep breaths, and move around.
3. Consciously state your purpose to yourself as you are focusing on your work. *For example, "Right now I am answering emails for the next thirty minutes."*

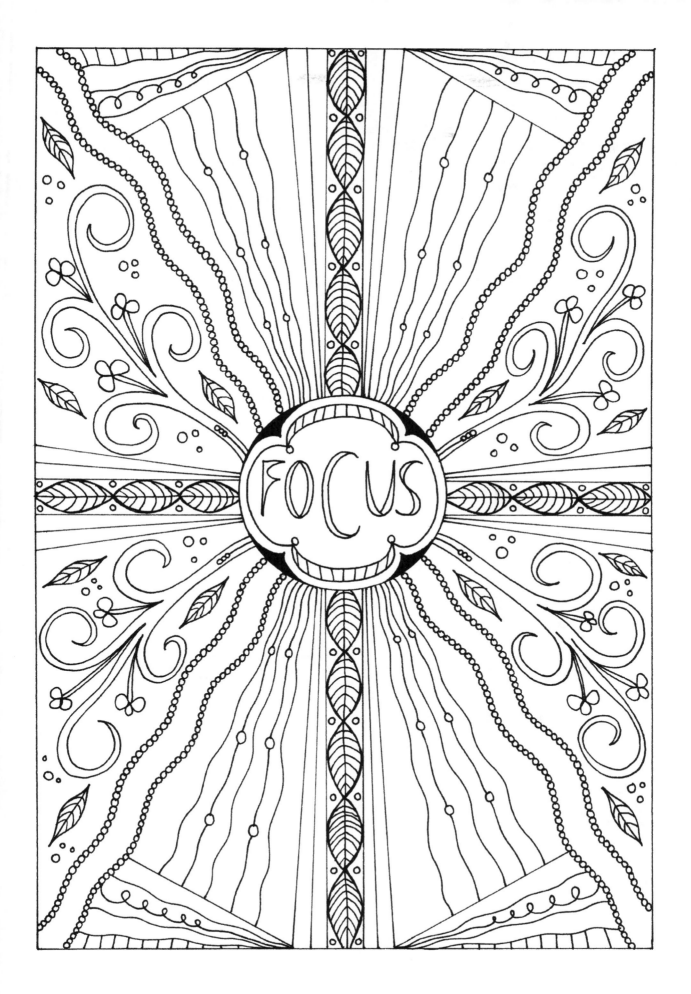

> "For to be free is not merely to cast off one's chains, but to live in a way that respects and enhances the freedom of others."
> ~ NELSON MANDELA

COLORING TIP

As you color, repeat one of the affirmations and give thanks for your freedom to think what you choose and be who you choose.

AFFIRMATIONS

Choose an affirmation and repeat several times daily, or during meditation:

1. Freedom is my right, my choice, and the basis of my life.
2. I am free to be the person I choose to be.
3. As I breathe deeply, I feel the liberating sense of freedom flowing through my body.

MINI MEDITATION

Get comfortable and breathe slowly. You may close your eyes or leave them open. Imagine you have been given a whole day to yourself to do whatever you wish to do with no responsibilities. How would you spend your day? Don't limit yourself, but don't think that you have to squeeze in as much as possible either. If you just want to lay on the couch and watch movies, so be it. If you want to go skydiving and have dinner at a gourmet restaurant, or jump on a plane and travel, imagine that. If you think you couldn't afford something, give yourself a virtual budget to spend. Dwell on the amazing sense of freedom that comes from this. It can also give you insight into what it is you really want in your life.

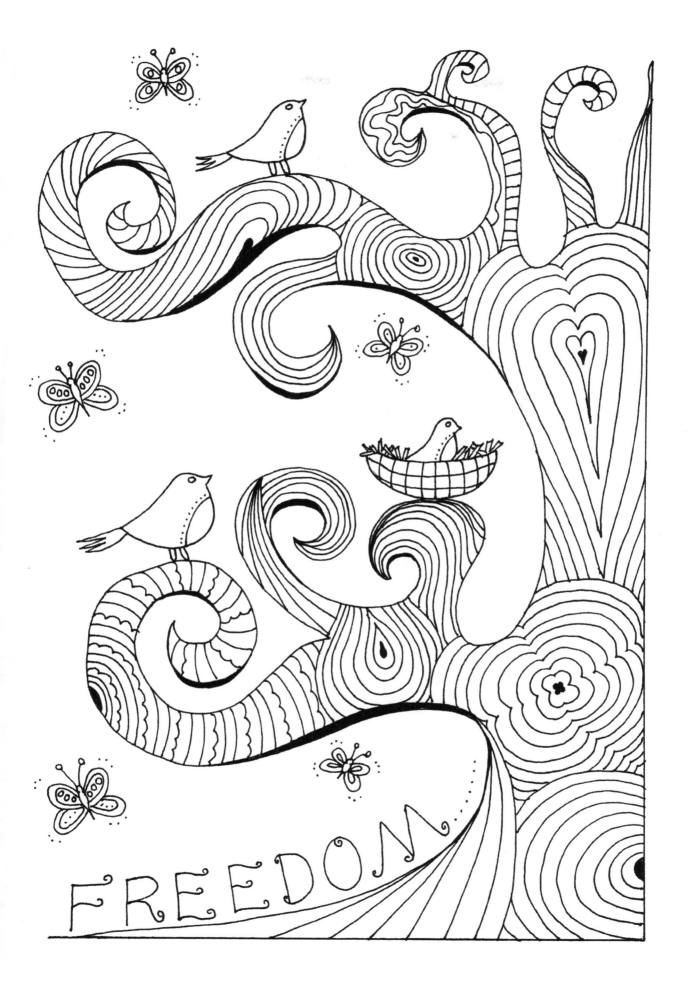

> "Even though you're growing up,
> you should never stop having fun."
> ~ NINA DOBREV

COLORING TIP

Allocate a different color for each of three different ways to have fun in your life, and focus your mind on each as you color.

AFFIRMATIONS

Choose an affirmation and repeat several times daily, or during meditation:

1. I allow myself to experience fun each day.
2. I bring a sense of fun to everything I do.
3. Life is a fabulous, fun journey and I wake with enthusiasm each day.

THREE WAYS TO EXPERIENCE FUN IN MY LIFE

List things that are fun for you. It can be helpful to think of things you enjoyed as a child.
For example, creating art, eating out with friends, dancing to music around the house.

1. ..
2. ..
3. ..

THREE WAYS I CAN HELP OTHERS EXPERIENCE FUN

List ways you could help others experience fun. *For example, host a costume party, plan a picnic and treasure hunt, plan a weekend away with friends.*

1. ..
2. ..
3. ..

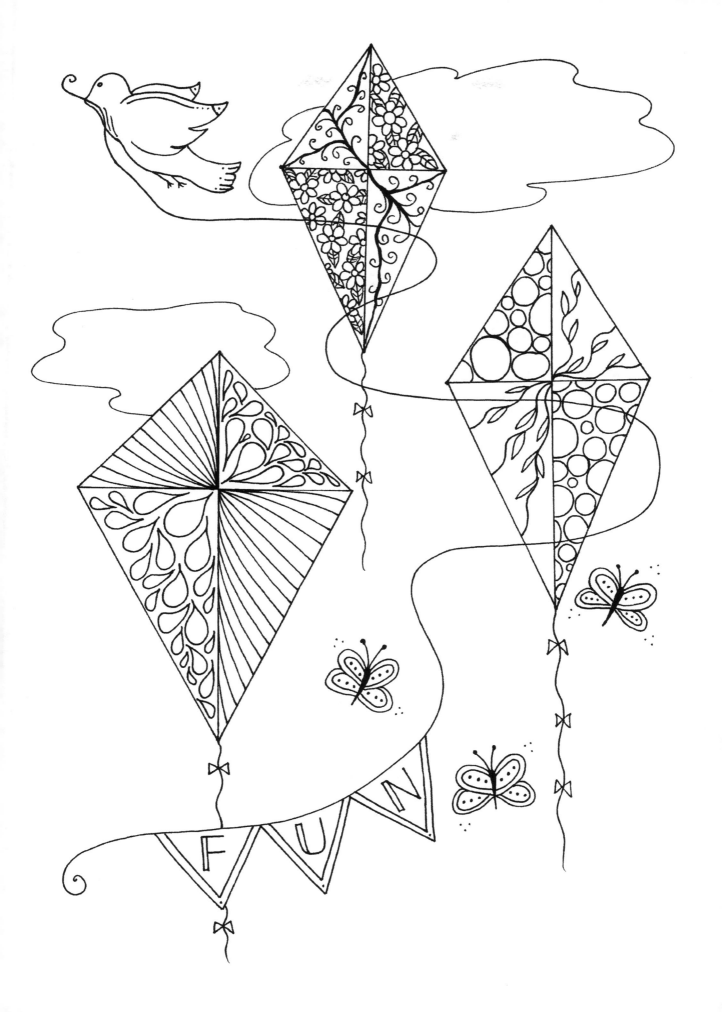

> "True generosity is an offering; given freely and out of pure love. No strings attached. No expectations. Time and love are the most valuable possession you can share."
> ~ SUZE ORMAN

COLORING TIP

As you color each of the circles, imagine what gift you would love to give important people in your life. Feel your desire for generosity being a gift in itself.

AFFIRMATIONS

Choose an affirmation and repeat several times daily, or during meditation:

1. I am so filled with joy and gifts I cannot help but share them with the world.
2. I see opportunities each day to be more generous.
3. I am both a giver and receiver of generosity.

THREE WAYS TO BE MORE GENEROUS

You can be generous with time, money, advice, practical help, love, and in many other ways.

1. Offer to babysit someone's children.
2. Cook a meal for a friend, or give them a gift basket of food.
3. Give compliments to everyone you interact with today.

RECEIVING GENEROSITY

List examples of times you have been a recipient of generosity.

1. ..
2. ..
3. ..

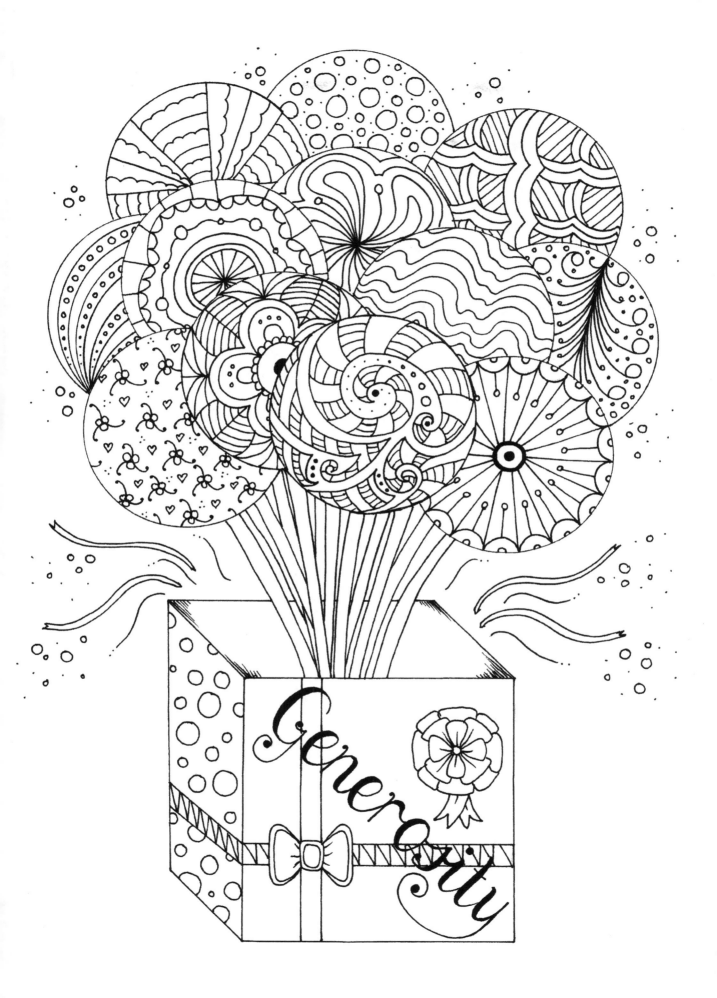

> "The greatest gift in life is
> to be remembered."
> ~ KEN VENTURI

COLORING TIP

Allocate one of your talents or gifts to each of the letters of the word *gift*. As you color, focus on feeling grateful for your gift.

AFFIRMATIONS

Choose an affirmation and repeat several times daily, or during meditation:

1. Life is a gift. I am a gift. I am surrounded by gifts.
2. When I open my eyes each morning I welcome the gift of a new day.
3. I am ready to share my gifts with others.

MY GIFTS

List your gifts and talents, and also gifts you've been blessed with in life. *For example, artistic talent, healthy children, stable home.*

1. ...
2. ...
3. ...
4. ...
5. ...

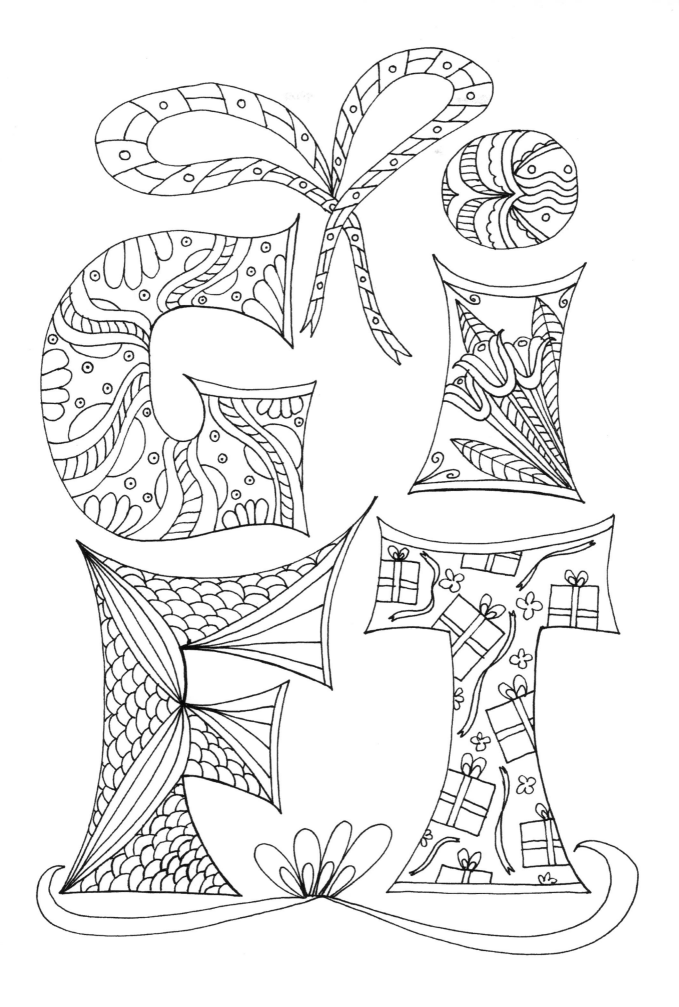

> "Every time you don't follow your inner guidance, you feel a loss of energy, loss of power, a sense of spiritual deadness."
> ~ SHAKTI GAWAIN

COLORING TIP

As you color, think about an issue for which you'd like guidance, and note down any keywords or insight.

AFFIRMATIONS

Choose an affirmation and repeat several times daily, or during meditation:

1. I have all the guidance I need within.
2. Today I intend to receive a sign to guide me on my path.
3. When I need guidance, I ask for help and receive it.

MINI MEDITATION

Do this before you go to sleep. On a piece of paper, write down an issue for which you'd like guidance. *For example, I would like guidance about what to do about my current difficult situation at work, I would like guidance about what career is best for me.* Hold the piece of paper and close your eyes. Imagine the feeling you will get when you have received guidance. Place the paper under your pillow and go to sleep. When you wake, pick up the piece of paper and imagine you have received this question from someone else. Write down your answer for them. Don't worry about being right or wrong, just write what comes to mind. Repeat this each night and morning if needed until deeper guidance appears.

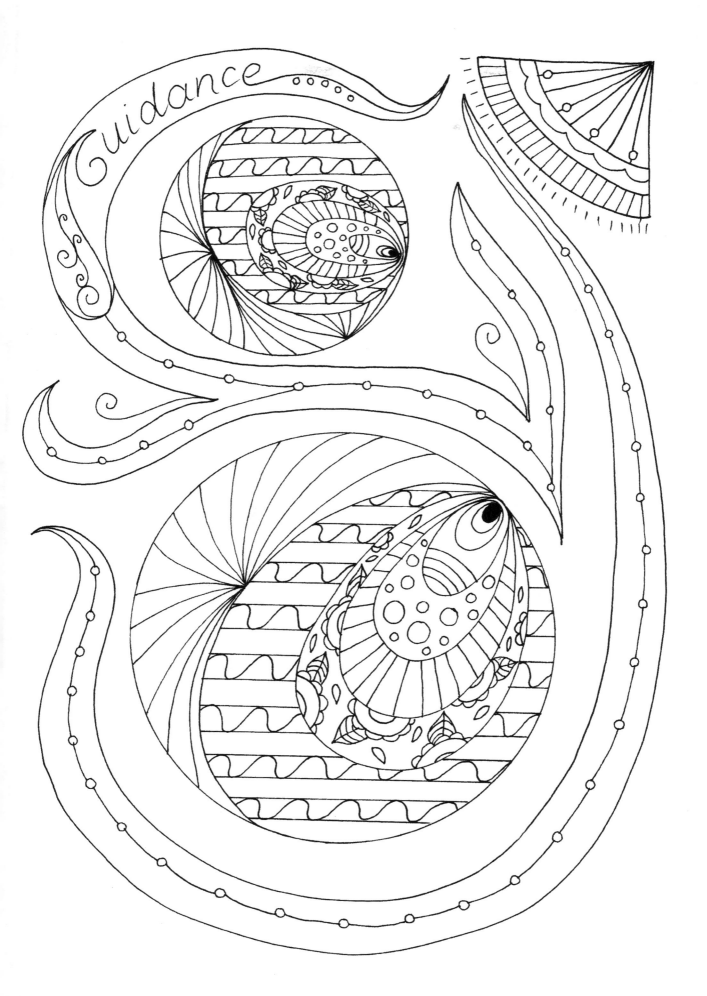

> "Most folks are about as happy as
> they make up their minds to be."
> ~ ABRAHAM LINCOLN

COLORING TIP

As you color, think of all the things in your life that make you happy.

AFFIRMATION

Repeat this affirmation several times daily, or during meditation:

I am responsible for my own happiness and choose to be happy.

I AM HAPPY BECAUSE…

Complete the sentence, "I am happy because…", writing down anything that comes to mind about why you are already happy. *For example, I have a best friend whom I can laugh with, I can see beautiful things in the world with my eyes, I am working in a job I love, because I choose to be.*

1. ..
2. ..
3. ..
4. ..
5. ..

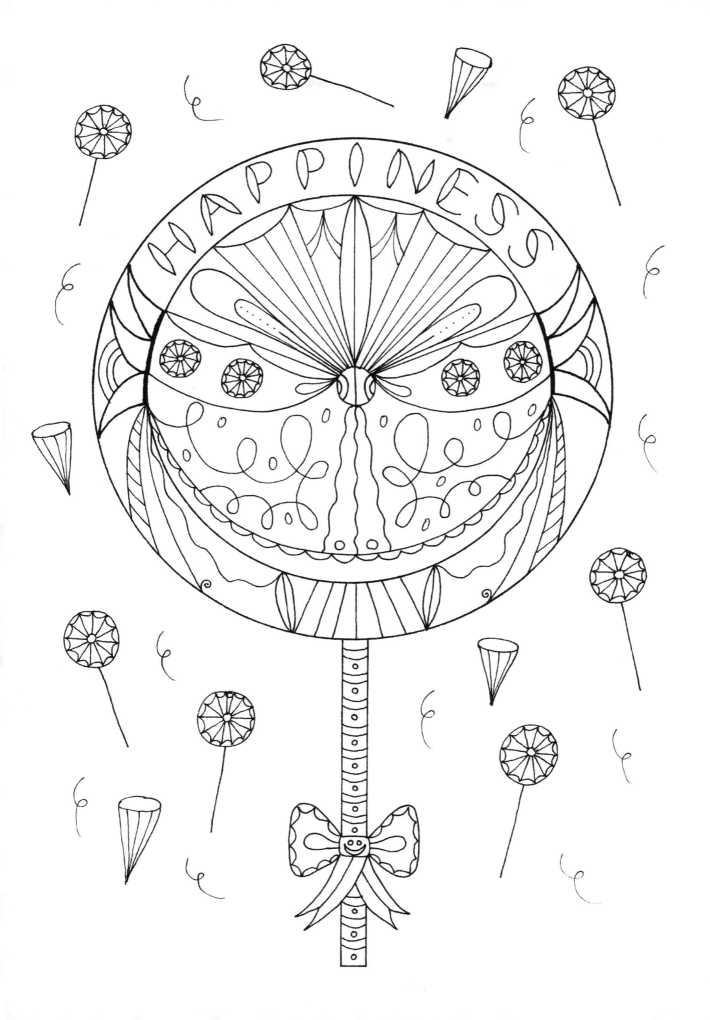

> "Healing is a matter of time,
> but it is sometimes also a
> matter of opportunity."
> ~ HIPPOCRATES

COLORING TIP

Imagine that every section you color is like a medicine, healing whatever you need healing for, whether it be your body, mind, or heart.

AFFIRMATIONS

Choose an affirmation and repeat several times daily, or during meditation:

1. When I provide my mind and body with healthy nourishment, healing is a natural result.
2. My body has a strong, innate healing power.
3. I love knowing my body is healing itself right now.

MINI MEDITATION

Lie down and close your eyes (cover them with an eye pillow if it helps). Take a deep breath and with your exhalation say "thank you"—for the fact that you are able to draw a breath and be alive. Feel the simple gift of your breath. Focus on an area that needs healing; a part of your body, your mind, or your heart if your pain is emotional. See it surrounded by healing white light, and imagine the area softening and lightening. Say to yourself, "Thank you for the healing taking place right now." When you feel peace in this area, open your eyes and smile.

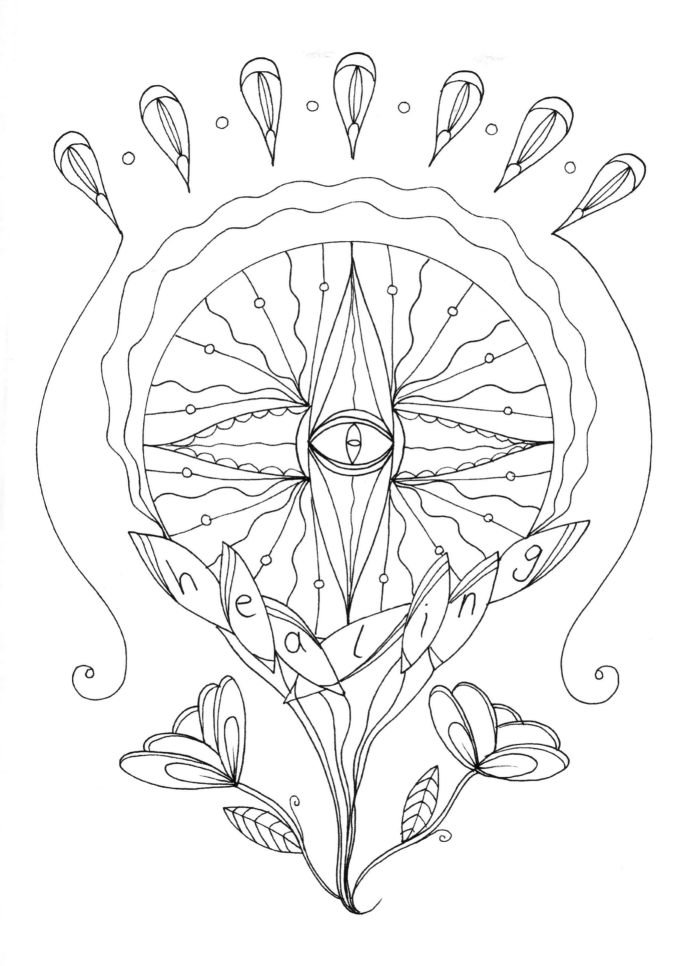

> *"You know, all that really matters is that the people you love are happy and healthy. Everything else is just sprinkles on the sundae."*
> ~ PAUL WALKER

COLORING TIP

As you color, imagine the illustration as a visual example of your healthy body, and bask in the sensations of what it feels like to be healthy.

AFFIRMATIONS

Choose an affirmation and repeat several times daily, or during meditation:

1. I am healthy, I am strong, I am complete.
2. Each day is an opportunity for me to improve my health.
3. My cells are buzzing with the natural energy of health.

THREE TIPS FOR BEING NATURALLY HEALTHY

1. Eat a healthy diet with a variety of protein, vegetables and fruits, nuts and seeds, and natural, unprocessed foods.
2. Make time for things you enjoy, and prioritize relaxation.
3. Surround yourself with positive people and stimuli. Switch off the news, and read empowering articles and books.

THREE THINGS I CAN DO THIS WEEK TO IMPROVE MY HEALTH

Often we know what positive changes we need to make to improve our health. Write three things that come to mind.

1. ..
2. ..
3. ..

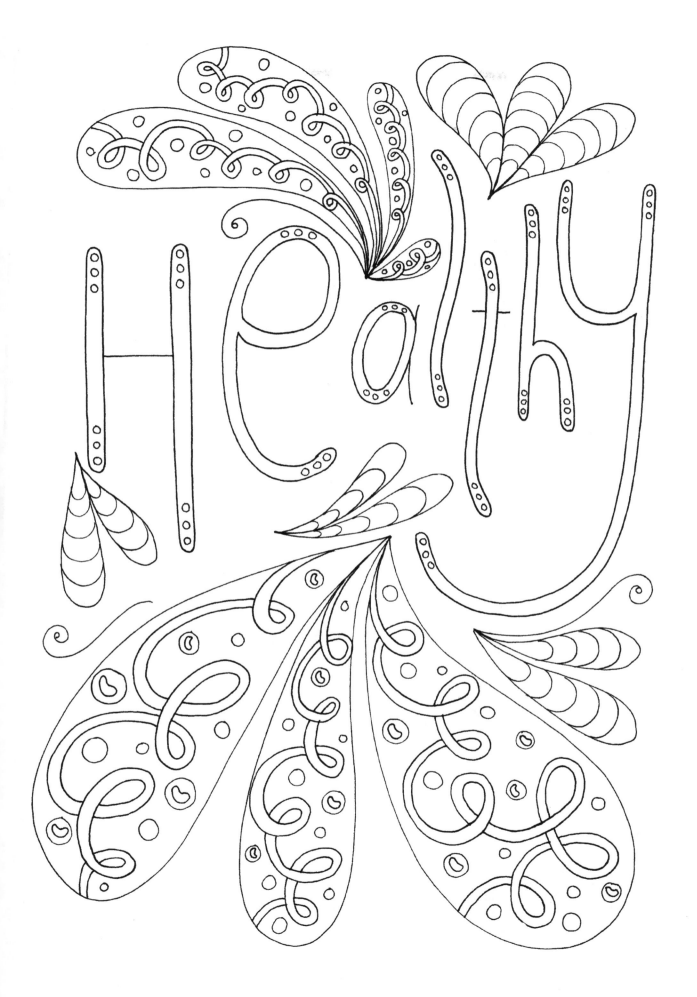

> "The best and most beautiful
> things in the world cannot be
> seen or even touched—they
> must be felt with the heart."
> ~ HELEN KELLER

COLORING TIP

As you color, listen to your heart. Is there something you are feeling that needs to be expressed, or something that needs to be done to follow your heart?

AFFIRMATIONS

Choose an affirmation and repeat several times daily, or during meditation:

1. When I follow my heart only positive outcomes can occur.
2. I listen to my heart and trust its guidance.
3. It is safe to open my heart and let people in.

MINI MEDITATION

Sit or lie down and cross your hands over your heart. Take several deep breaths, feeling your heart expand with each. Imagine the sensation of love filling your heart until it is so full it cannot help but radiate this love. Now send rays of love and light from your heart to certain people or to the world around you in general. See them receiving this love from your heart to theirs. You may also wish to say the person's name, and then, "I am sending love from my heart to yours."

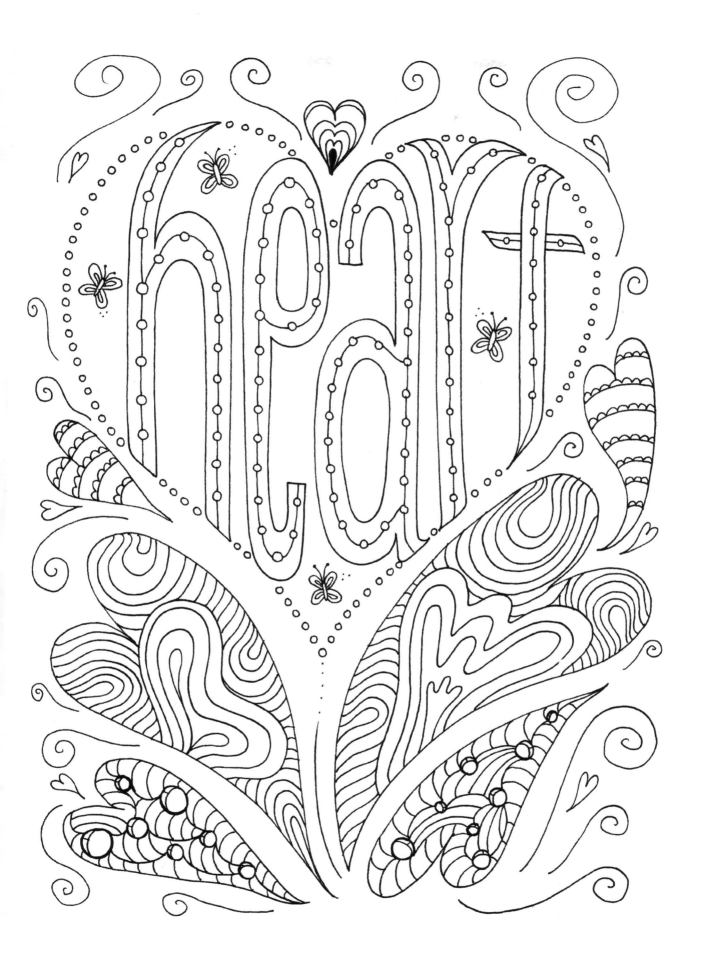

> "Never make your home in a place. Make a home for yourself inside your own head. You'll find what you need to furnish it—memory, friends you can trust, love of learning, and other such things. That way it will go with you wherever you journey."
> ~ TAD WILLIAMS

COLORING TIP

Focus on the attributes of your ideal home or living environment as you color. If you're in your ideal home, focus on what you love about it.

AFFIRMATIONS

Choose an affirmation and repeat several times daily, or during meditation:

1. My home is a place I can feel safe, loved, and comforted.
2. My body is my home, and I keep it clean, nourished, and loved.
3. I keep the comforting feeling of home with me wherever I go.

MY IDEAL HOME

This is a useful exercise if you are looking for a new home, or want to improve your current living situation. List attributes that would make your living environment ideal, from details about the house itself, to location, neighbors, and the experiences you would have there. *For example, near the beach, quiet street, room for dinner parties, close to work.*

1. ..
2. ..
3. ..
4. ..
5. ..

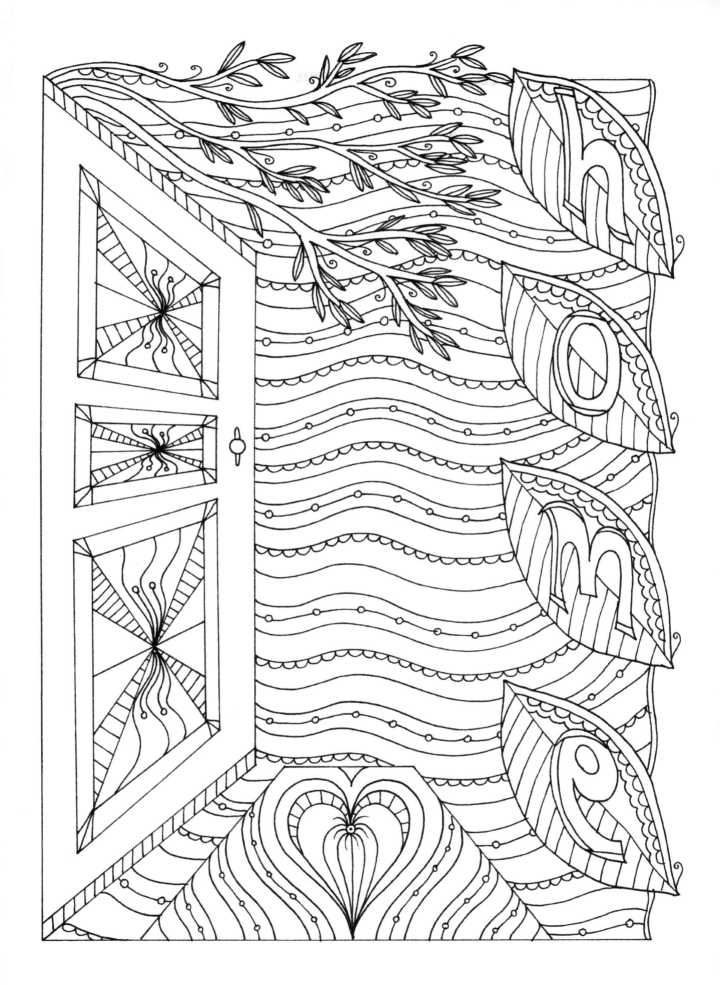

> "Hope is the pillar that holds up the world. Hope is the dream of a waking man."
> ~ PLINY THE ELDER

COLORING TIP

When you finish coloring each of the hope balloons, think of a hope you have, and imagine it floating up to the sky to be taken care of.

AFFIRMATIONS

Choose an affirmation and repeat several times daily, or during meditation:

1. No matter what I am going through, there is always hope.
2. Hope lights my way forward.
3. I believe in the power of hope to keep me strong and happy.

MINI MEDITATION

Close your eyes and take a few deep breaths. Release any areas of tension in your body with your exhalations. Think about hopes you have in your life, even if they feel unattainable. If you have hope, you have potential and possibility. State each hope, and feel the emotion of what it would be like if it were true. Then imagine tying this hope onto a balloon and releasing it into the sky, knowing that a greater power is taking care of it.

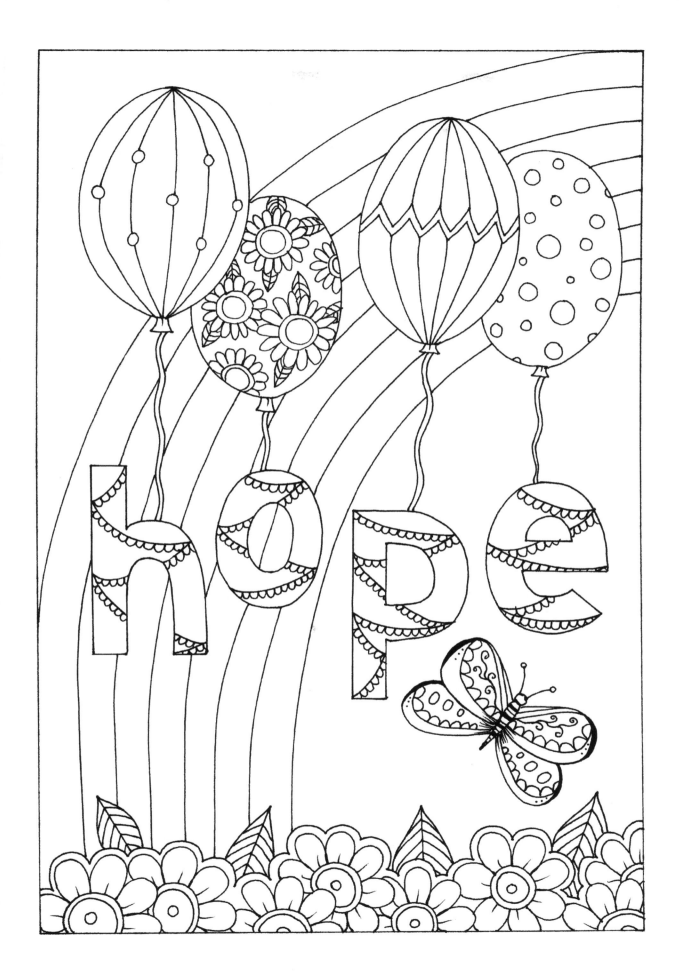

> "No matter what people tell you, words and ideas can change the world."
> ~ ROBIN WILLIAMS

AFFIRMATIONS

Choose an affirmation and repeat several times daily, or during meditation:

1. I have an abundance of ideas at my beck and call.
2. Ideas come to me when I need them most.
3. By opening my mind to new ideas, I open my life to new opportunities.

THREE TIPS FOR ENCOURAGING NEW IDEAS

1. Go for a walk or do some form of exercise. Movement can encourage momentum and allow your thoughts to be clearer.
2. Flip through a magazine to see if anything catches your attention.
3. Take a shower and imagine the water is showering you with thousands of ideas.

THREE IDEAS I HAVE RIGHT NOW

After trying one or more of the above (if needed), write down any ideas you have. They may be ideas relating to solutions you need to come up with, a work situation or challenge, a creative pursuit, home decorating, anything that requires an idea.

1. ..
2. ..
3. ..

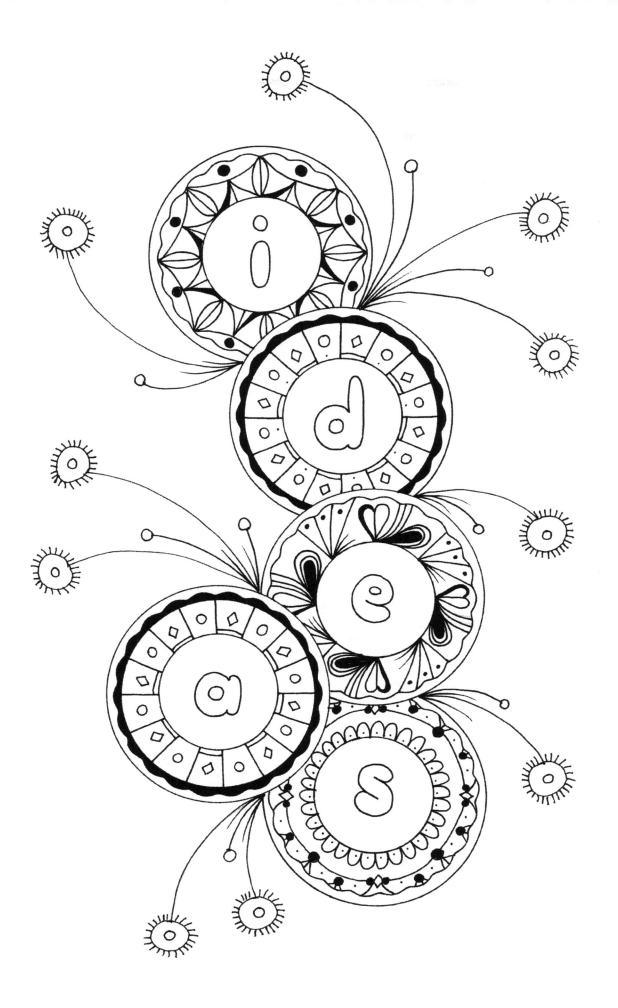

> "Imagination is the beginning of creation. You imagine what you desire, you will what you imagine, and at last you create what you will."
> ~ GEORGE BERNARD SHAW

COLORING TIP

As you color, think like a child and imagine what your ideal fantasy world would be like. There are no limits; be creative and use your imagination!

AFFIRMATIONS

Choose an affirmation and repeat several times daily, or during meditation:

1. I maintain a childlike sense of wonder at all things.
2. My imagination is a valuable tool to help me achieve my goals.
3. If I can imagine it, I can achieve it.

MINI MEDITATION

Close your eyes and relax your body by taking several slow, deep breaths. Think of either a situation that has already occurred that you wished had gone differently, or an upcoming situation. For the past situation, imagine how you would have liked it to have unfolded. What would you or others have said or done differently? This is not to dwell on what you can't change, but to train your imagination to creatively prepare you for similar situations in the future. For an upcoming situation, imagine how you would like it to play out, like a scene in a movie. Not to fixate on a specific outcome or try to control it, but to stimulate positive possibilities. Your brain doesn't always know if what it is imagining is real or pretend. Don't be surprised if sometimes, things happen just as you imagined them.

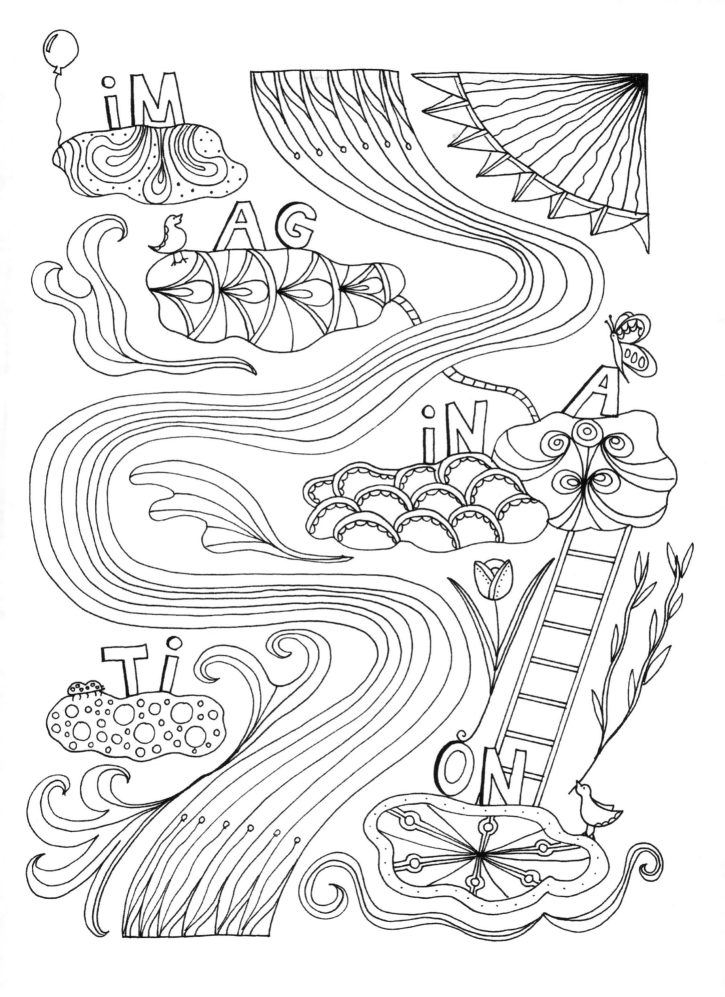

> "A moment's insight is sometimes
> worth a life's experience."
> ~ OLIVER WENDELL HOLMES SR.

COLORING TIP

Think of a question or topic, and as you color, take note of any insights, keywords, ideas, or answers that come to mind.

AFFIRMATION

Repeat this affirmation several times daily, or during meditation:

I am open to receiving amazing moments of insight that benefit my life.

THREE TIPS TO GAIN MORE INSIGHT IN YOUR LIFE

1. Meditate regularly and listen to your inner guidance.
2. Write in a journal every day, letting your thoughts roam free.
3. Read a new, empowering, and educational book each month.

MINI MEDITATION

Close your eyes and take three deep breaths. Feel the muscles in your body softening and relaxing. Focus on your breathing until you feel calm and relaxed. Imagine a large book in front of you, radiating light. It contains unlimited insight and ideas to help you in all areas of your life. Think of a question or issue of significance to you, and imagine how you will feel when you gain clarity about it. Focus on those feelings. Ask the book your question, or for general insight, and wait for it to flip open to a page by itself. In your mind's eye, look at the page. What do you see? An image? Words? Or do you get a feeling? Thank the book for its help and slowly open your eyes.

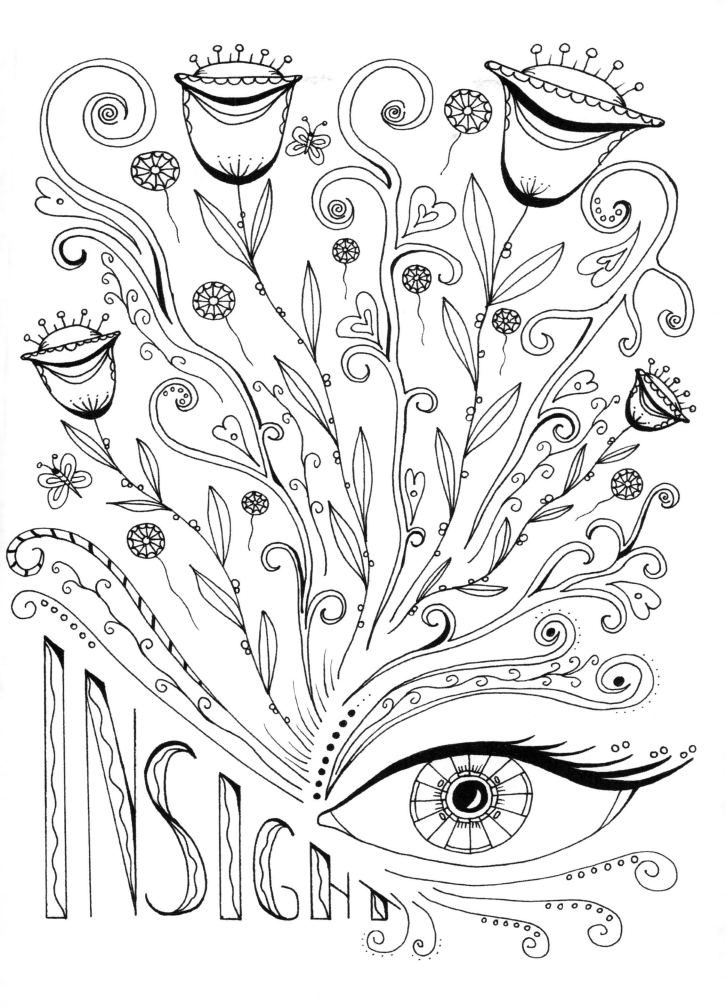

> "True inspiration overrides all fears. When you are inspired, you enter a trance state and can accomplish things that you may never have felt capable of doing."
> ~ BERNIE SIEGEL

AFFIRMATIONS

Choose an affirmation and repeat several times daily, or during meditation:

1. I see inspiration everywhere I go.
2. By feeling inspired and acting on inspiration, I inspire others.
3. Whenever I need inspiration, I can always look to nature.

THREE PEOPLE OR THINGS THAT INSPIRE ME

List things or people who inspire you, whether you know them personally or have seen them in the media. *For example, a beautiful flower, the ocean, children playing.*

1. ..
2. ..
3. ..

THREE WAYS I CAN INSPIRE OTHERS

List ways you can inspire others. *For example, being an example of good health, using positive words and phrases in conversation, telling people what you like about them.*

1. ..
2. ..
3. ..

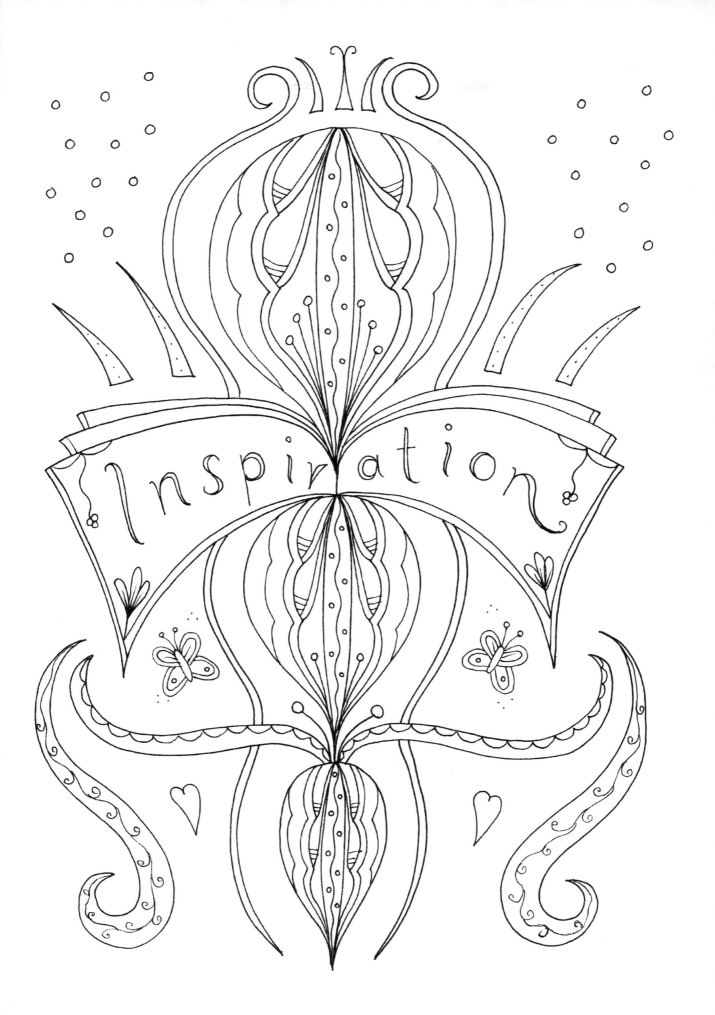

> *"Our intention creates our reality."*
> ~ DR. WAYNE W. DYER

COLORING TIP
Choose one specific intention you would like to make, and write an intention statement. Repeat this statement to yourself as you color.

AFFIRMATIONS

Choose an affirmation and repeat several times daily, or during meditation:

1. When I set an intention and focus on being happy, miracles happen.
2. Clear and specific intentions bring clear and specific results.
3. My mind has the power to deliberately create an intended result.

Intentions are powerful tools to manifest what you desire. By getting clear about what you want, you are more likely to be open and aware of relevant opportunities and more likely to attract what you intend into your life. The first key is to get clear and specific, the second key is to make choices each day that match your intention, and the third key is to not fixate or obsess about it but let things happen in their own natural way. Take inspired action when appropriate but don't force your intention into reality.

MY INTENTIONS

For example, I intend to go to bed with a huge smile on my face, I intend to receive unexpected assistance, I intend to know with certainty what step to take next.

For today: ..

...

For this week: ..

...

For this month: ..

...

For this year: ..

...

> "The more you trust your intuition,
> the more empowered you become,
> the stronger you become, and
> the happier you become."
> ~ GISELE BÜNDCHEN

AFFIRMATIONS

Choose an affirmation and repeat it several times daily, or during meditation:

1. I trust that my intuition knows what is best for me.
2. My intuition guides me through all of life's challenges.
3. I am an intuitive and powerful being and life is on my side.

TIMES THAT MY INTUITION HAS HELPED ME IN MY LIFE

List examples of times that your intuition served you well. *For example, went a different route to work and avoided an accident, made a decision based on instinct that turned out well, took a leap of faith.*

1. ...
2. ...
3. ...

THREE TIPS TO DEVELOP YOUR INTUITION

1. Meditate daily, and when you are completely relaxed, allow any thoughts or feelings to come to you, or ask a question and let an answer form.
2. Notice your immediate thought or feeling when faced with a question or situation. Our first response is usually accurate, before the memory of our past experiences and limiting beliefs can get in the way.
3. If you have a specific question about something in your life, ask the question and see what answers come to you as you color the illustration.

> "Sometimes it's the journey
> that teaches you a lot about
> your destination."
> ~ DRAKE

AFFIRMATIONS

Choose an affirmation and repeat several times daily, or during meditation:

1. When enjoying the journey, the destination doesn't matter.
2. I am enjoying and making the most of the adventurous journey of life.
3. I trust in my unique journey to lead me on the right path.

MY JOURNEY SO FAR

Make a list of milestones or significant moments that have occurred in your life journey, like a timeline. Focus on the positive, though if any were challenging, focus on something positive that resulted from it.

1. ..
2. ..
3. ..

I LOOK FORWARD TO...

List future milestones you look forward to on your continuing life journey. *For example, having a baby, graduating, taking a vacation.*

1. ..
2. ..
3. ..

> ## "Joy is the best makeup."
> ~ ANNE LAMOTT

AFFIRMATIONS

Choose an affirmation and repeat several times daily, or during meditation:

1. I experience moments of pure joy each day.
2. I am open to receiving a continual stream of joy into my life.
3. By being joyful, I radiate joy and bring joy to others.

THREE WAYS TO EXPERIENCE JOY IN MY LIFE

List things that bring you joy. *For example, singing, walking in nature, playing with a child, writing poetry, watching the sunrise.*

1. ..
2. ..
3. ..

THREE WAYS I CAN SPREAD JOY TO OTHERS

List ways you could help others experience joy. *For example, leave an anonymous gift for someone, buy flowers for a friend, make someone laugh.*

1. ..
2. ..
3. ..

> "No act of kindness, no matter how small, is ever wasted."
> ~ AESOP

AFFIRMATIONS

Choose an affirmation and repeat several times daily, or during meditation:

1. By being kind, I attract kindness into my life.
2. It is a joy to spread kindness around the world.
3. Every interaction I take part in is an opportunity for kindness.

RANDOM ACTS OF KINDNESS CHALLENGE

When you spread kindness, kindness comes back to you. But don't be kind in order to receive kindness; be kind for the sheer pleasure it brings you. Random or anonymous acts of kindness are a great way to add a touch of something special to your life and the lives of others. It is incredibly rewarding to know you have made someone's day, even if you're not there to see it. Try doing one or more of these things, and add your own ideas to the list. Maybe even join forces with a friend and have a kindness weekend completing various tasks.

1. Leave money with a shop assistant and tell them you'd like it to help pay for the next customer's purchase.
2. Leave a small anonymous gift for someone to find.
3. Write a letter of encouragement for a stranger and leave it in their mailbox or inside a book at the library.

MY IDEAS:

1. ..
2. ..
3. ..

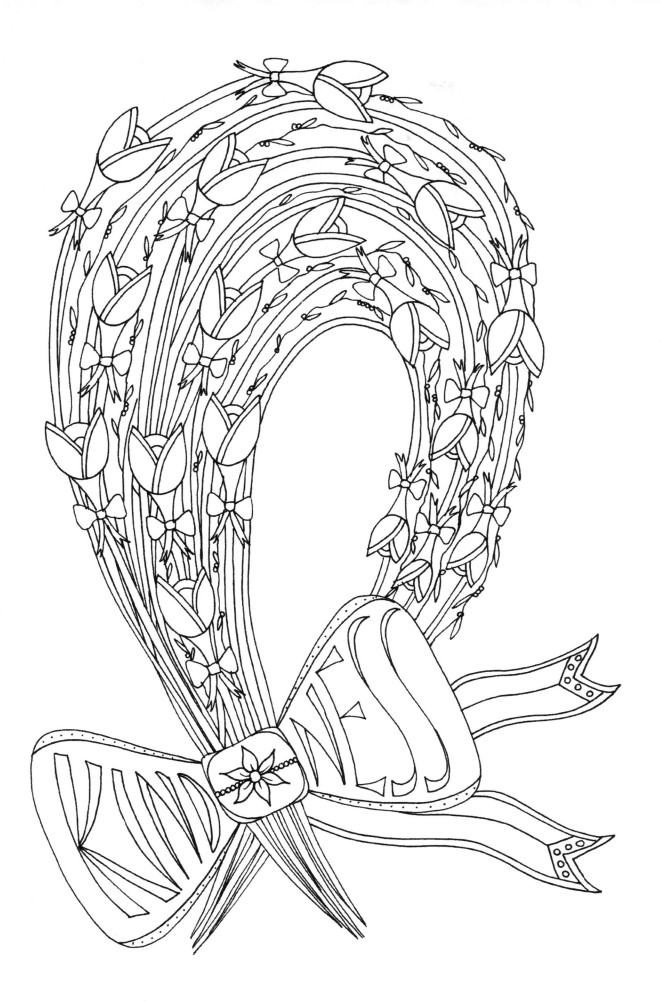

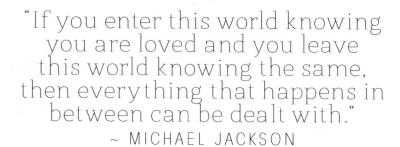

> "If you enter this world knowing
> you are loved and you leave
> this world knowing the same,
> then everything that happens in
> between can be dealt with."
> ~ MICHAEL JACKSON

AFFIRMATIONS

Choose an affirmation and repeat several times daily, or during meditation:

1. I trust, I believe, I know, that everything is happening just as it should.

2. I know that the best is yet to come, and I am excited about the future.

3. My dreams are supported by an inner sense of knowing that they are manifesting right now.

Having a strong sense of certainty is a surefire way to attract and manifest what you are wanting. When you believe one hundred percent, anything is possible.

I KNOW THAT...

Complete the sentence, "I know that...", by writing down things that you have a deep sense of certainty about. *For example, I know that my health is improving every day, I know that I will find the right job for me, I know that everything will be okay.*

1. ...

2. ...

3. ...

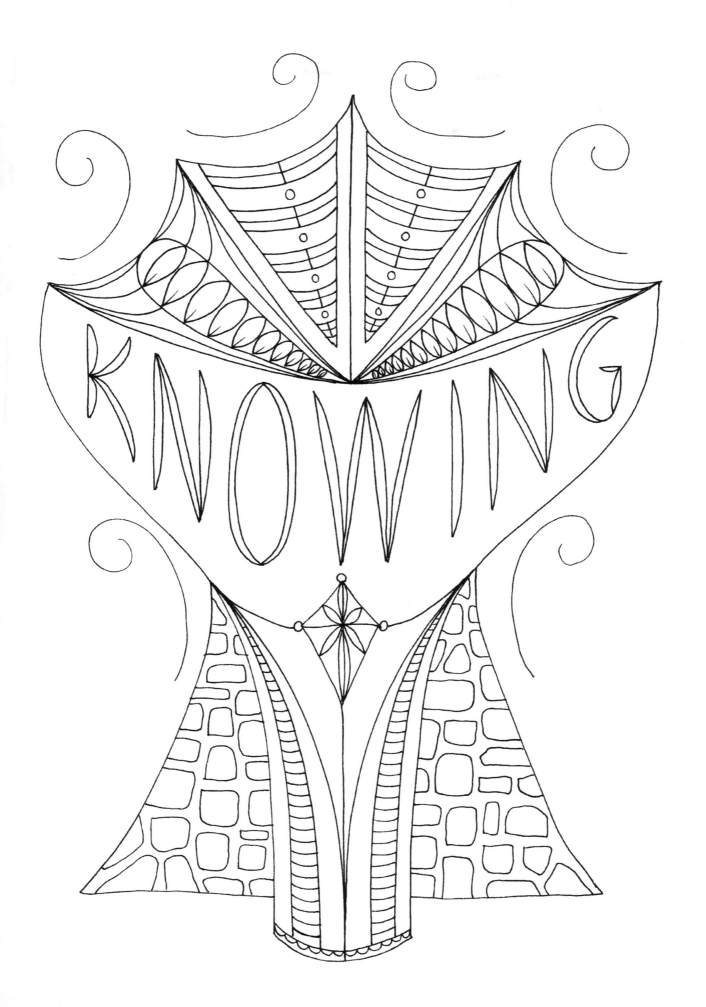

> "A sense of humor…is needed armor. Joy in one's heart and some laughter on one's lips is a sign that the person down deep has a pretty good grasp of life."
> ~ HUGH SIDEY

COLORING TIP

As you color, recall moments in your life when you've had a good belly laugh. Remembering laughter can be just as beneficial as laughing itself.

AFFIRMATIONS

Choose an affirmation and repeat several times daily, or during meditation:

1. I consciously make time in life for things that make me laugh.
2. I can turn any challenging day around with the magic of laughter.
3. I love that laughter is a regular occurrence in my life.

MY LAUGHTER LIST

Laughter is an amazing healing and happiness tool. List people, experiences, TV shows, movies, or anything you can think of that makes you laugh. Refer to this list whenever you need a pick-me-up.

1. ..
2. ..
3. ..
4. ..
5. ..

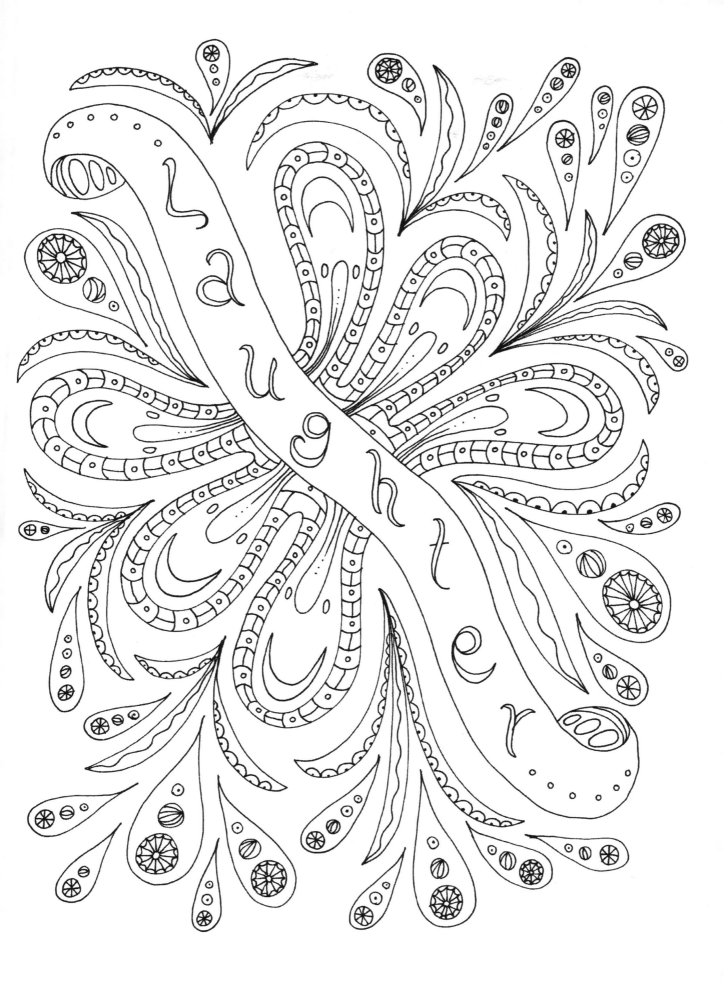

AFFIRMATIONS

Choose an affirmation and repeat several times daily, or during meditation:

1. The more I teach others, the more I learn myself.
2. I choose to learn something new today.
3. Every person I meet has something to teach me.

THREE THINGS I'VE LEARNED

List things you've successfully learned to do in your life, whether it be something practical, or a mental skill. *For example, learned to cook, to respond to pressure calmly and rationally, to meditate.*

1. ..
2. ..
3. ..

THREE THINGS I WANT TO LEARN

List anything you would like to learn but haven't yet. *For example, a practical skill, a sport, a mind-body technique, a dance style, a profession.*

1. ..
2. ..
3. ..

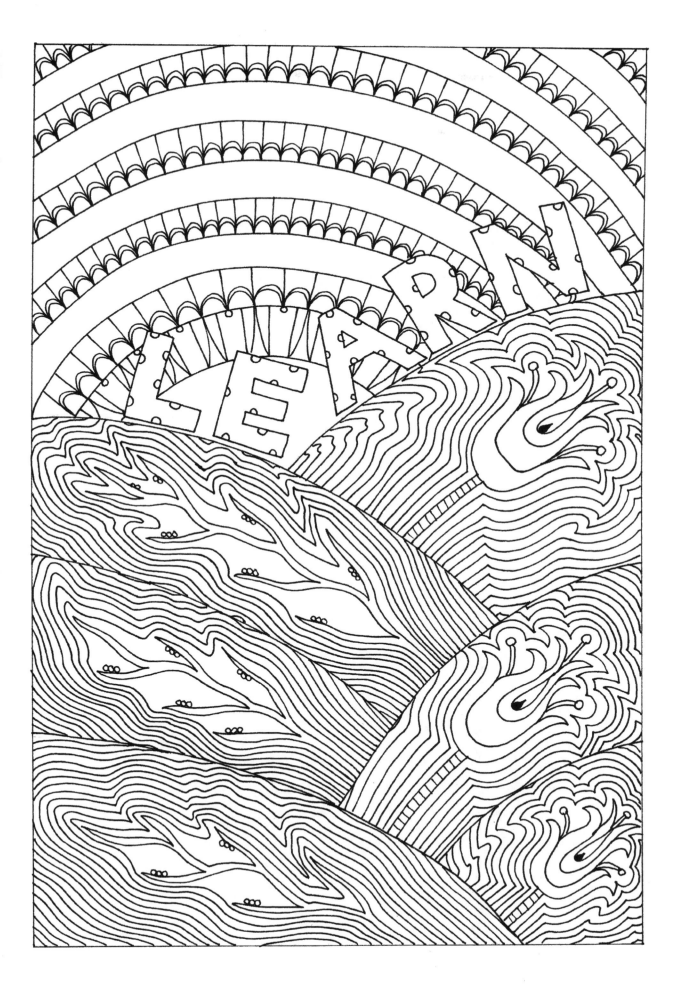

"Where there is love there is life."
~ MAHATMA GANDHI

AFFIRMATIONS

Choose an affirmation and repeat several times daily, or during meditation:

1. I am ready to be more loving toward myself.
2. I am love, I give love, I receive love.
3. All the cells of my body are bathed in love.

MINI MEDITATION

Do this brief meditation whenever you are feeling stressed, nervous, frustrated, or angry. Repeat as many times as needed:

Close your eyes and take three deep breaths; with the first inhalation say in your mind "I," with the second inhalation say "Am," and with the third say "Love." Before you open your eyes, smile, and imagine your heart open, light, and radiating love.

THREE WAYS I CAN SHOW MORE LOVE TO MYSELF

List ways you can express more love for yourself. *For example, have a "me date" each week doing something I love, choose healthy food, say "no" sometimes.*

1. ...
2. ...
3. ...

THREE WAYS I CAN SHOW MORE LOVE TO OTHERS

List ways you can express more love to others. *For example, tell people what I appreciate about them, help a friend in need, give someone a hug.*

1. ...
2. ...
3. ...

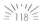

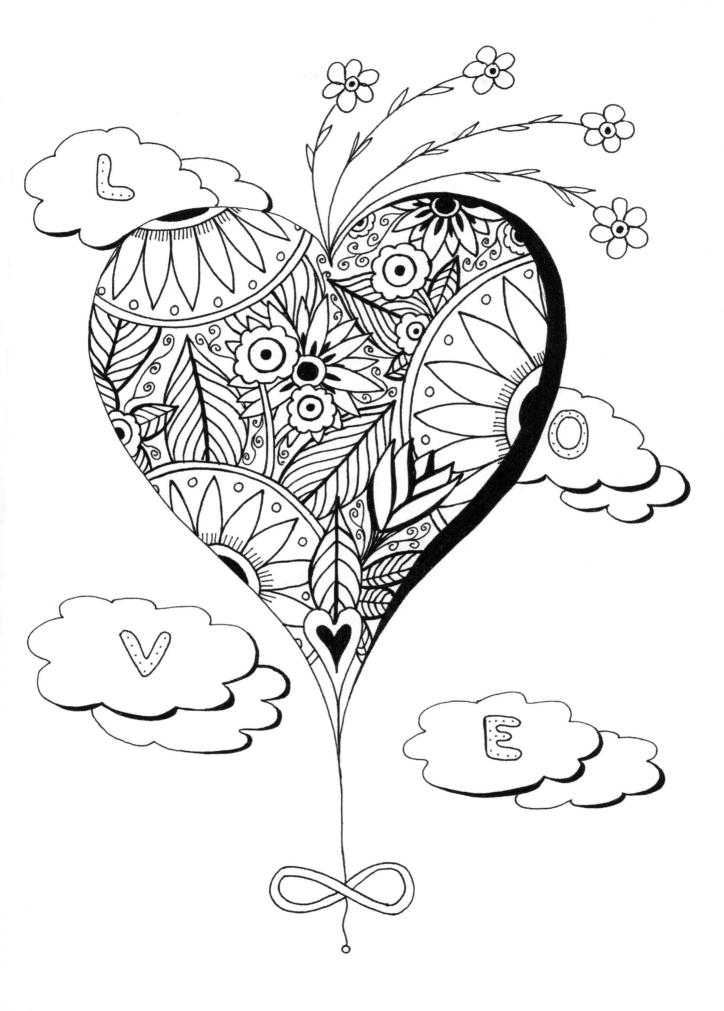

> "I wish that all of nature's magnificence, the emotion of the land, the living energy of place could be photographed."
> ~ ANNIE LEIBOVITZ

AFFIRMATIONS

Choose an affirmation and repeat several times daily, or during meditation:

1. I expect and receive magnificence in my life experience.

2. I see the magnificence in everyone and everything around me.

3. I love knowing that at my core I am a magnificent being and everyone is equal.

MINI MEDITATION

This is one you do with your eyes open. If you are visually impaired you can use your sense of touch.

Choose three or more objects or points of focus (e.g., a vase, a flower, a piece of jewelry, the ocean, a mountain, a beautiful building, etc.). Focus on each, one at a time. Revel in the magnificence of the object or focal point. Really feel appreciation for how amazing it is: the design, the colors, the texture, its purpose, the beauty, etc. Don't be surprised if you find yourself getting emotional as you tune into its magnificence and feel gratitude for its presence in the world.

> "Every great work, every big accomplishment has been brought into manifestation through holding to the vision, and often just before the big achievement, comes apparent failure and discouragement."
> ~ FLORENCE SCOVEL SHINN

COLORING TIP

As you color, imagine the swirling design working to create your desired manifestation. Each color you add is fuel for your desire to become reality.

AFFIRMATION

Repeat this affirmation several times daily, or during meditation:

Manifestation is a result of my thinking and beliefs, and I choose thoughts and beliefs that align with what I want to manifest.

THREE DESIRES I WANT TO MANIFEST

List three things you wish would show up in your life. Then complete the mini meditation to help in your manifestation journey.

1. ...
2. ...
3. ...

MINI MEDITATION

Do a separate meditation for each of your three desires. Close your eyes and relax your body. Repeat the desire to yourself three times, then think about what this actually means for you. How would this look if it showed up in your life? If you opened your eyes and it had manifested, how would things be different? What would you see, hear, feel, etc.? Use your imagination to create a full sensory story of the experience as though it is already real.

"With mindfulness, you can establish
yourself in the present in order
to touch the wonders of life that
are available in that moment."
~ THÍCH NHẤT HẠNH

COLORING TIP
Coloring is a mindfulness activity in itself! As you color, simply pay attention to the process and enjoy being in the moment.

AFFIRMATIONS
Choose an affirmation and repeat several times daily, or during meditation:

1. Each day I make time for activities that encourage mindfulness.
2. As I perform this task, I am completely in the moment with it.
3. I remain mindful of the present moment as I move through the day.

MINDFULNESS ACTIVITY
At various moments throughout the day, focus on what you are doing in the present moment. Continue doing it, but with a heightened sense of awareness and mindfulness. Observe each movement, watch the process unfold, notice every detail and aspect of it. Practicing this regularly helps you to become more mindful of living in the moment.

OPPORTUNITIES FOR MINDFULNESS
List moments when you could be more mindful. *For example, while doing housework, during exercise, experiencing nature.*

1. ..
2. ..
3. ..

> "Miracles happen every day, change your perception of what a miracle is and you'll see them all around you."
> ~ JON BON JOVI

COLORING TIP

As you color the miracle bubbles, focus on miracles that have occurred in your life and miracles you would love to occur in your life.

AFFIRMATIONS

Choose an affirmation and repeat several times daily, or during meditation:

1. Miracles occur when the wisdom of my heart and soul is listened to and acted upon.
2. Miracles are not rare, they are everywhere.
3. Miraculous moments occur frequently in my life.

MY MIRACLE LIST

Complete this sentence: "My life is miraculous because..." *For example, my heart beats constantly and keeps me alive, the right people have shown up for me at the right times, I have a job that supports me.*

1. ...
2. ...
3. ...
4. ...
5. ...

> "Enthusiasm is the energy and
> force that builds literal momentum
> of the human soul and mind."
> ~ BRYANT H. MCGILL

COLORING TIP

As you color, focus on the feeling of momentum that propels your pencil or marker across the page.

AFFIRMATIONS

Choose an affirmation and repeat several times daily, or during meditation:

1. By focusing joyfully on each moment in time, I create a powerful forward momentum.
2. I am moving forward with positive momentum.
3. Natural momentum is taking me where I need to go.

MOMENTUM MAP

Create a momentum map to track movement toward your goal(s). Write your goal in the middle of a piece of paper, then as small steps or milestones are achieved, write them on a branch shooting out from the center. Keep adding progress as it occurs and watch how much momentum you are creating.

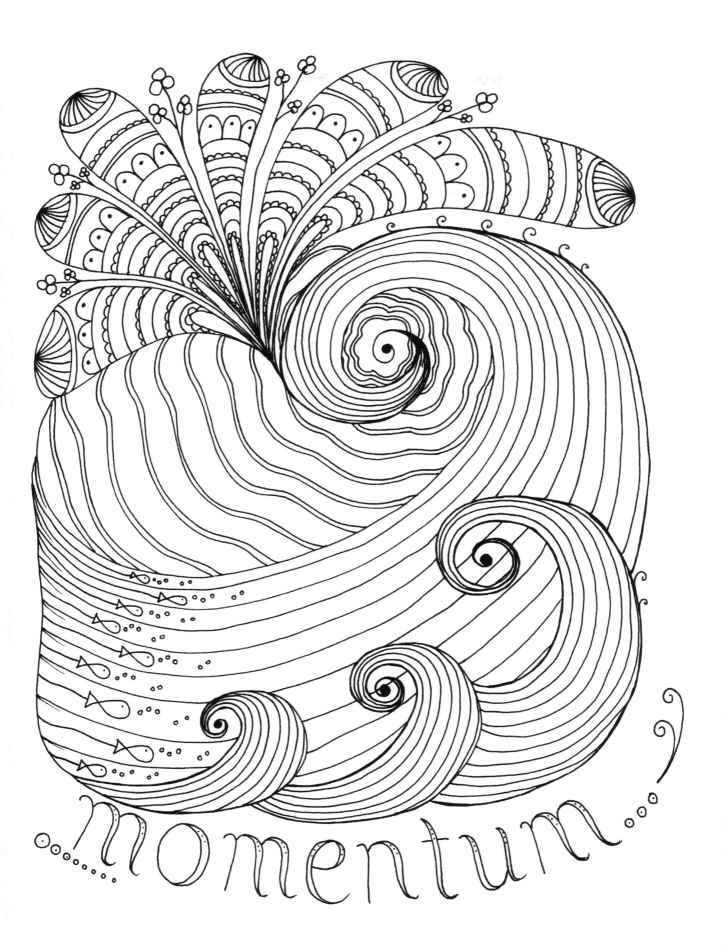

> "Nature does not hurry, yet
> everything is accomplished."
> ~ LAO TZU

COLORING TIP
Use colors you associate with nature to create your colored illustration. Alternatively, use colors opposite to what you'd expect to see in nature to create something different.

AFFIRMATIONS
Choose an affirmation and repeat several times daily, or during meditation:

1. I can achieve calm and balance whenever I tune into nature.
2. Nature is my inspiration, and I follow its lead.
3. My life and health are supported by the power of nature.

THREE THINGS TO DO IN NATURE
Here are three ideas to make the most of nature:

1. Go for a walk or jog along the beach.
2. Have a picnic in a beautiful natural environment.
3. Go camping or sleep under the stars.

THREE THINGS I CAN DO IN NATURE
Write a list of three enjoyable things you could do to make the most of nature, either taking ideas from the above list or coming up with your own.

1. ...
2. ...
3. ...

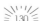

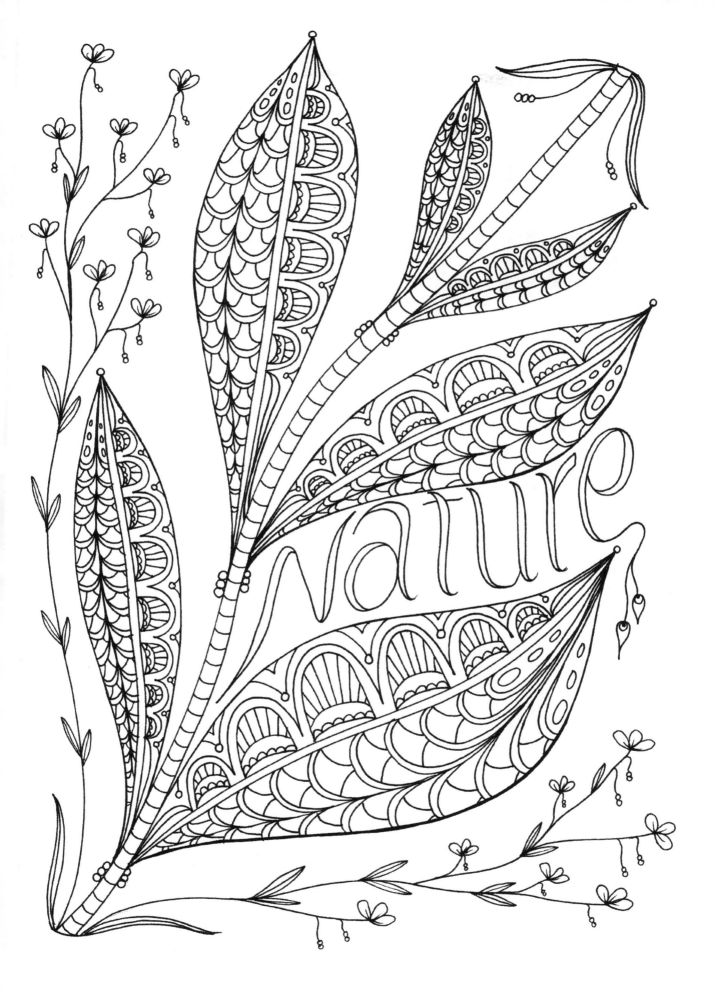

> "Your big opportunity may be
> right where you are now."
> ~ NAPOLEON HILL

COLORING TIP

As you color, focus on the present moment. With each stroke of the pencil or marker, say, "I am here right now" or "All is well right now."

AFFIRMATIONS

Choose an affirmation and repeat several times daily, or during meditation:

1. I am living in the now. Now, now, and now.
2. I love that life is happening right now and I can choose how to enjoy this moment.
3. Whenever I need to, I can achieve calm by focusing on the now.

THREE ACTIVITIES THAT HELP ME LIVE IN THE NOW

Write a list of three things that relax you and make you feel more aware of the present moment. *For example, coloring, gardening, meditating.*

1. ...
2. ...
3. ...

Multitasking can reduce your productivity. Instead, focus on one task at a time. As you move from one activity to the next in your day, consciously switch your focus. You can do this by saying to yourself, "I am now focusing on…"

> "Look at situations from all angles,
> and you will become more open."
> ~ DALAI LAMA

COLORING TIP

As you color, repeat one of the affirmations or simply imagine your heart and mind being open and receptive to new ideas and positive emotional experiences.

AFFIRMATIONS

Choose an affirmation and repeat several times daily, or during meditation:

1. I am open and ready for amazing people and opportunities to enter my life.
2. I am open to learning a new perspective today.
3. By being open with myself and others, I encourage openness and honesty in return.

OPENING YOUR HEART

Throughout life's challenges, it can be common to close ourselves off from new opportunities and experiences to protect ourselves from getting hurt. Try this exercise to practice opening your heart:

Close your eyes and see any past hurt as something visual in or around your heart. It could be a cage, a rock, a twisted rope, etc. Imagine this object being lifted from your body and placed into a dark box. See that box being carried away until it disappears. Now see the space where the hurt once was, and fill that space with healing light, the color of your choice. Imagine your heart opening up with new space to let love and positivity in. Say, "My heart is open and ready for love and positivity."

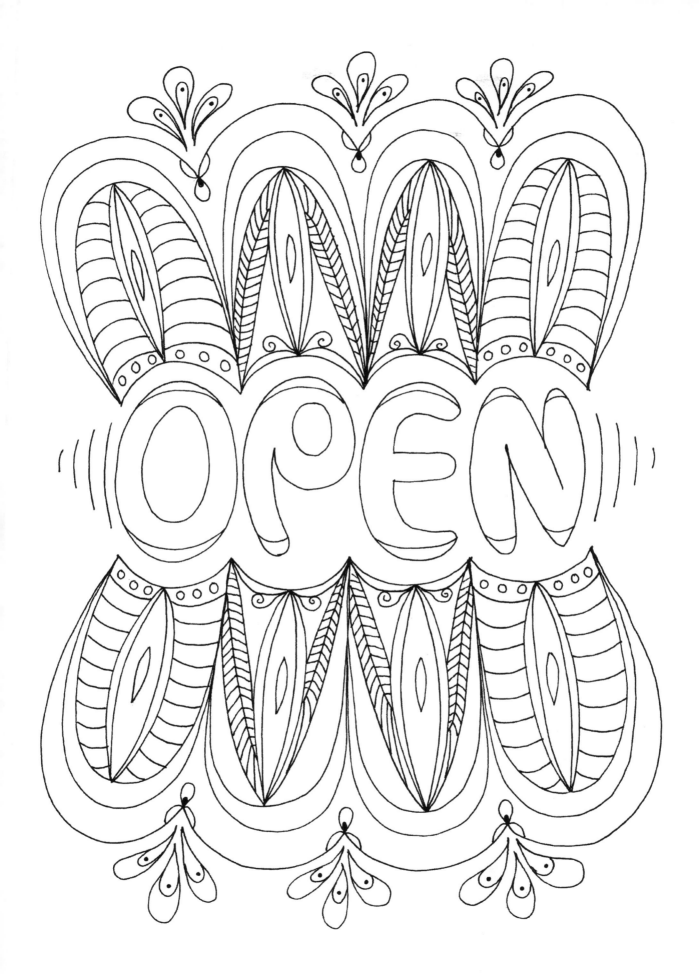

> "A pessimist sees the difficulty in every opportunity; an optimist sees the opportunity in every difficulty."
> ~ WINSTON CHURCHILL

COLORING TIP

As you color, think of the opportunities you'd like to receive. *For example, to start a new job, to make a new friend, to have more fun.*

AFFIRMATIONS

Choose an affirmation and repeat several times daily, or during meditation:

1. Today I intend to receive a wonderful opportunity.
2. Opportunities are everywhere and the right one is ready for me.
3. I take opportunities when they present themselves if they feel good to me.

THREE WAYS TO BE MORE OPEN TO OPPORTUNITIES

1. When you are faced with a challenge, consciously consider how it could create an opportunity for you.
2. Agree to a suggestion from someone and see where it leads.
3. Speak up and suggest an idea when you normally would be too afraid or nervous.

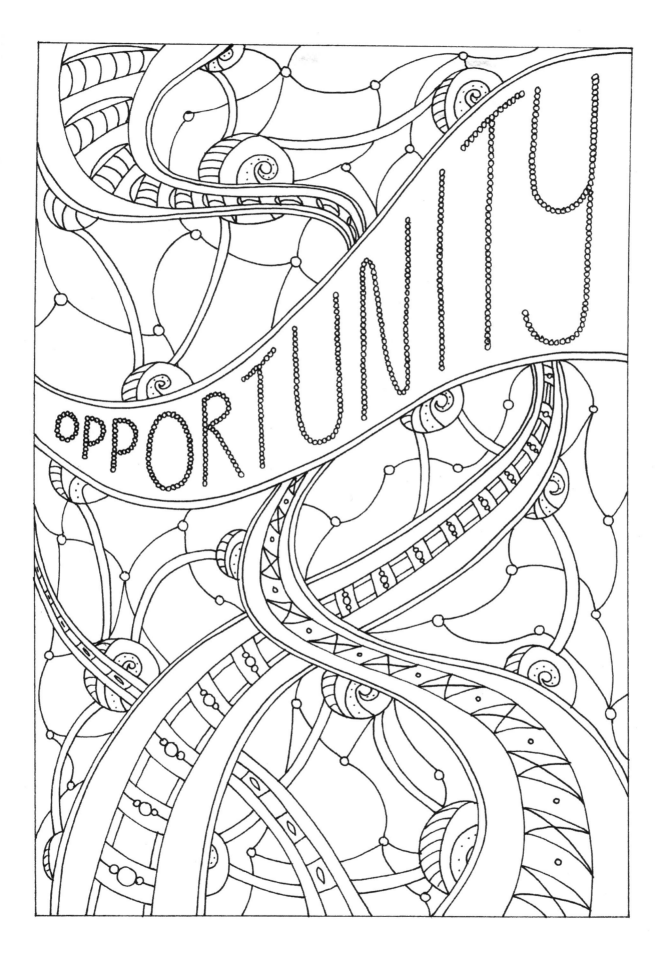

> *"Have the passion, take the action, and magic will happen."*
> ~ BAR REFAELI

AFFIRMATIONS

Choose an affirmation and repeat several times daily, or during meditation:

1. With passion, I can achieve anything I set out to do.
2. I promise to live my life with passion and purpose.
3. I love that I get to live my passions each day.

I AM PASSIONATE ABOUT...

List things that make you feel passion for life, including experiences or states of being that make you feel alive and authentic. *For example, helping people less fortunate, creating beautiful art to inspire others, spending quality time with my partner.*

1. ..
2. ..
3. ..
4. ..
5. ..

When you live a life aligned with your passions, amazing opportunities can open up to you. Follow your passions, not someone else's. They are your passions for a reason.

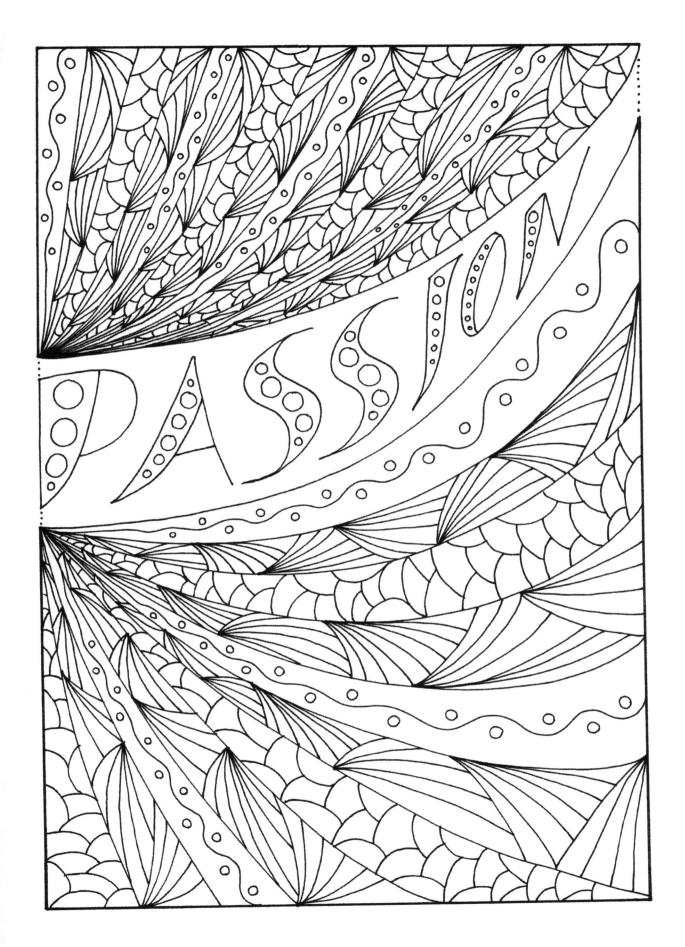

> "Patience is not simply the ability to wait—it's how we behave while we're waiting."
> ~ JOYCE MEYER

COLORING TIP

Consciously take your time to color the illustration. Notice any impatience that comes up, and say, "I am patient. Everything is happening at the perfect time."

AFFIRMATIONS

Choose an affirmation and repeat several times daily, or during meditation:

1. I am learning to be more patient with each passing day.
2. I choose to keep an eager yet calm sense of patience.
3. With each deep breath I trust that things are working out in perfect timing.

PATIENCE REQUEST

Write a list of things you would like to learn to be more patient with. Complete this sentence: "I ask to become more patient in relation to…" *For example, my children, my boss, finishing school, finding my soul mate, losing weight.*

1. ..
2. ..
3. ..

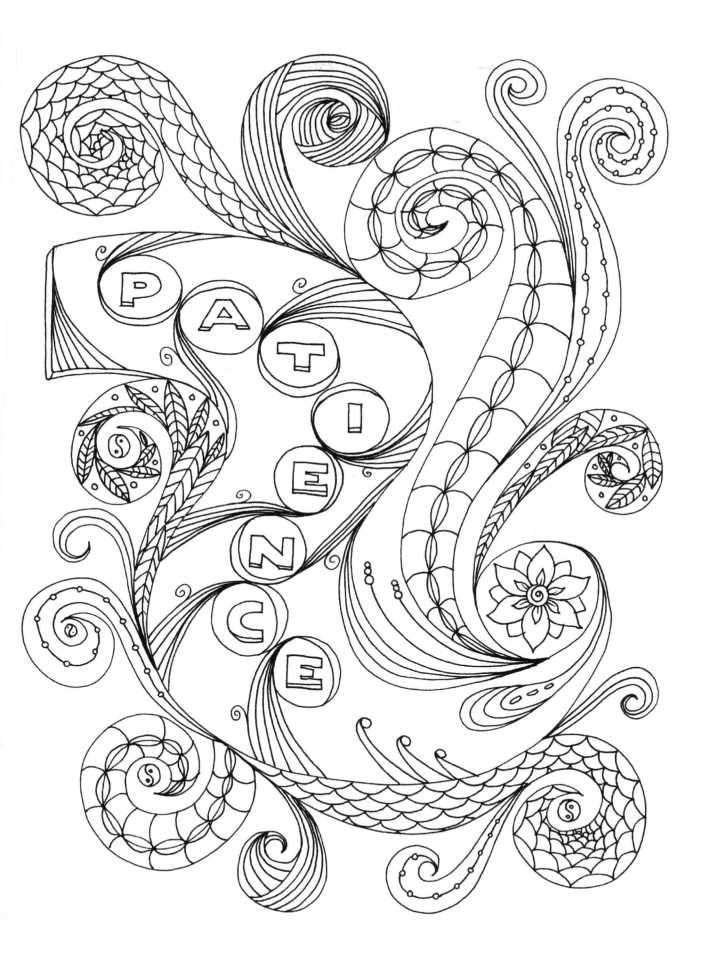

> "There is no greater wealth in this world than peace of mind."
> ~ ANONYMOUS

COLORING TIP

As you color, imagine sending peace in the form of each color to certain people, or even yourself, and replacing any anxiety with peaceful acceptance.

AFFIRMATIONS

Choose an affirmation and repeat several times daily, or during meditation:

1. I go about my day with a calm sense of peace.
2. I choose peace of mind to be my dominant experience.
3. By consciously being peaceful, I bring peace to others and attract a continuous stream of peace into my life.

THREE TIPS TO EXPERIENCE MORE PEACE IN LIFE

1. Instead of becoming irritated with someone's actions, try to imagine the situation from their point of view. Even if you don't agree, understanding can lead to acceptance and a greater sense of peace.
2. Let go of the need to be right, or to be recognized or validated. Be at peace knowing the truth yourself and appreciating your own value.
3. Don't suppress negative emotions when they appear. Let them flow in trust that they will eventually pass, and be at peace with knowing that emotional fluctuations are part of being human.

THREE WAYS I CAN FEEL MORE PEACEFUL

Complete the following sentence: "I feel peaceful when I..."

1. ..
2. ..
3. ..

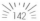

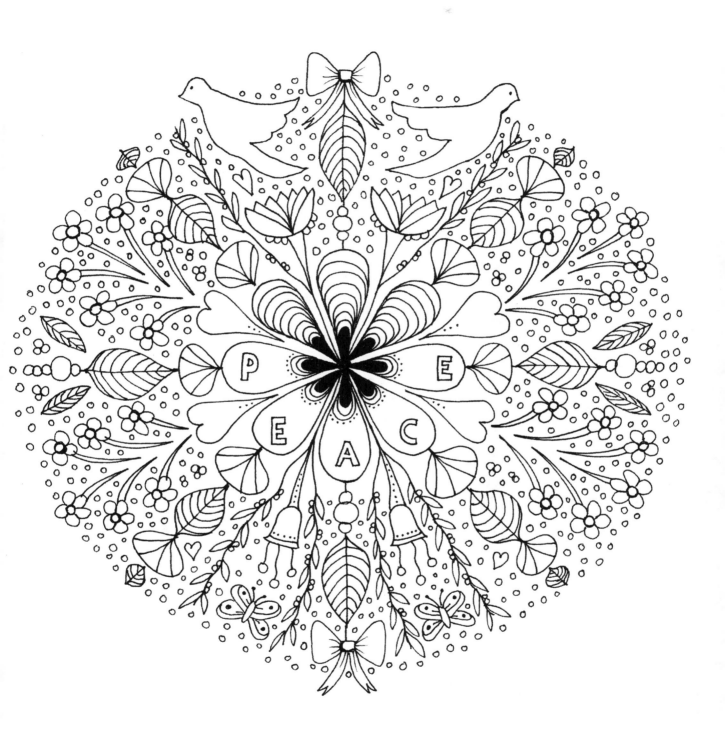

> "There are things known and there are things unknown, and in between are the doors of perception."
> ~ ALDOUS HUXLEY

AFFIRMATIONS

Choose an affirmation and repeat several times daily, or during meditation:

1. I can turn any situation around by choosing to alter my perception.
2. My perception is what creates my experience, and I choose positive perceptions and experiences.
3. I understand and accept differing perceptions.

PERCEPTION CHALLENGE

Think of a specific situation or a person that could elicit a variety of different opinions or perceptions. Note down your perceptions and opinions, then note down other people's perceptions and opinions. Now note down the facts about the situation or person. How many of the perceptions are based on fact? Notice how easy it is to form assumptions based on your own conditioning. Make an effort to be more aware and accepting of different perceptions and to not let judgment get in the way of fair treatment.

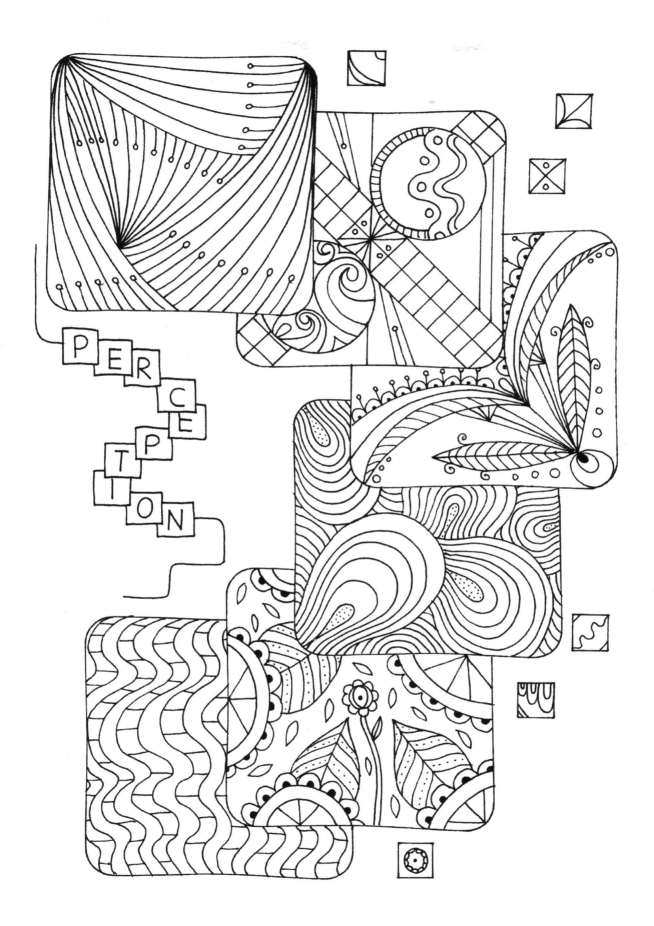

> "A positive attitude causes a chain reaction of positive thoughts, events, and outcomes. It is a catalyst and it sparks extraordinary results."
> ~ WADE BOGGS

COLORING TIP

As you color, recall all the positive experiences from your day or from the past week. Remind yourself of how many positives there are in the world.

AFFIRMATIONS

Choose an affirmation and repeat several times daily, or during meditation:

1. Every negative has its positive.
2. Positivity is everywhere if I choose to see it.
3. I live today with joy and positivity.

THREE WAYS I CAN BE MORE POSITIVE

List ideas of how you could demonstrate more positivity in day-to-day life. *For example, smiling at more people, giving someone a compliment, not allowing yourself to get upset over something trivial, seeing the humor in a situation.*

1. ..
2. ..
3. ..

POSITIVES FROM MY DAY OR WEEK

What positive things have you experienced recently?

1. ..
2. ..
3. ..

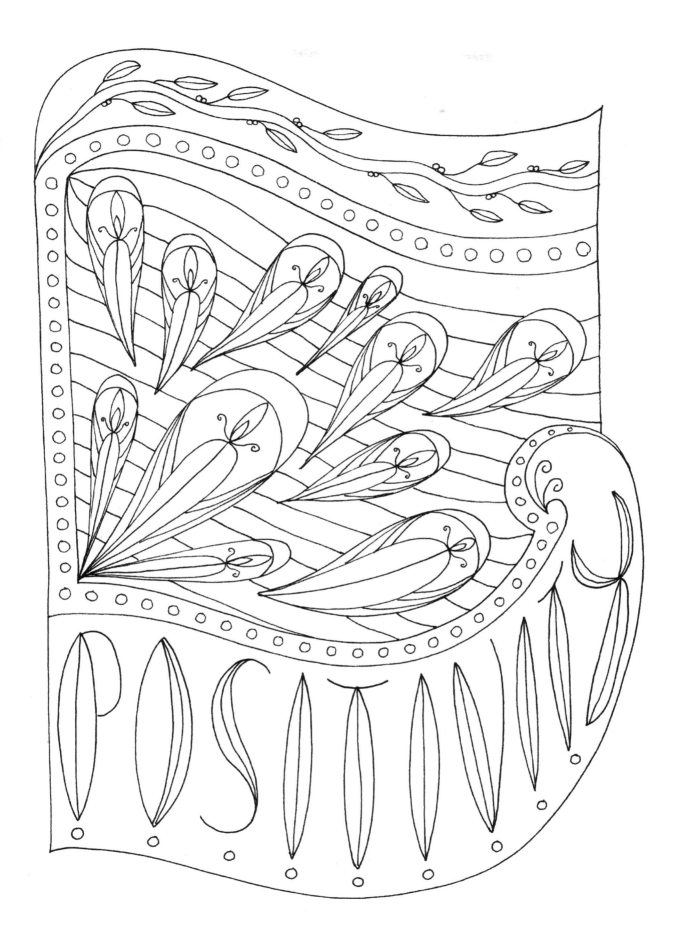

"I dwell in Possibility."
~ EMILY DICKINSON

COLORING TIP

Think of a situation you have a few doubts about. As you color, allow yourself to imagine all the positive possibilities that could result instead.

AFFIRMATIONS

Choose an affirmation and repeat several times daily, or during meditation:

1. I love knowing that there are unlimited possibilities available for me.
2. The best possibility may be one I have yet to discover.
3. I am staying open and receptive to possibilities greater than I imagined.

POSSIBILITY LIST

Think of a situation that is important to you but perhaps a bit daunting or doubtful in terms of whether it will work out the way you hope. Below, list five positive possibilities, even if you don't know how they could happen. *For example, if you are wondering if you'll be able to get a job in the area you want to work in, consider possibilities such as: I could find the perfect workplace and love going to work every day, I could meet someone tomorrow who has a connection in the industry, I could make great new friends in this new field.*

1. ..
2. ..
3. ..
4. ..
5. ..

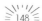

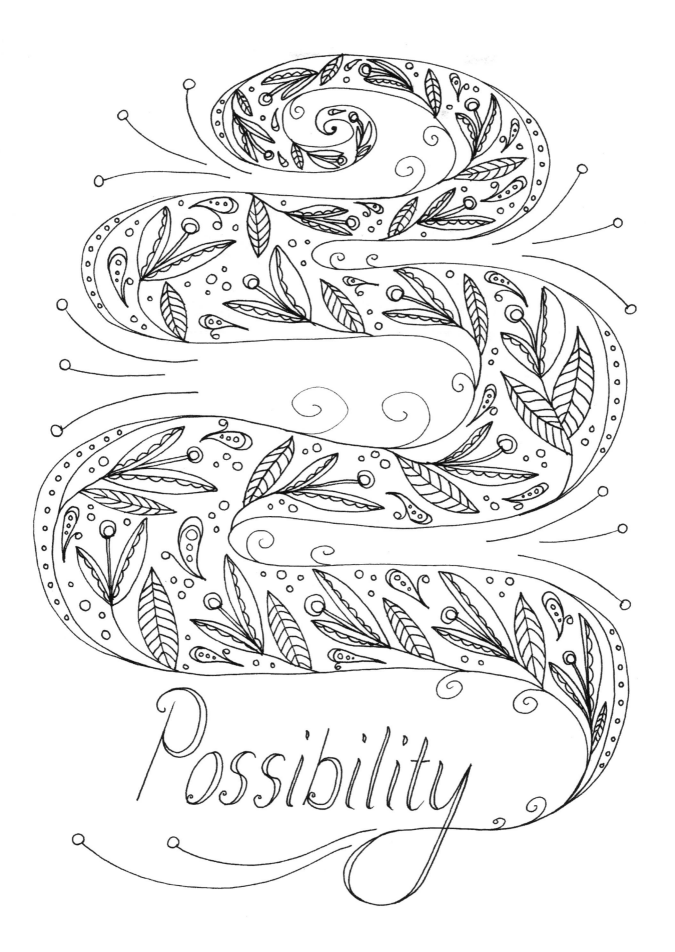

> "Consult not your fears but your hopes and your dreams. Think not about your frustrations, but about your unfulfilled potential. Concern yourself not with what you tried and failed in, but with what it is still possible for you to do."
> ~ POPE JOHN XXIII

AFFIRMATIONS

Choose an affirmation and repeat several times daily, or during meditation:

1. There is always untapped potential and today I am tuning in to mine.
2. I choose to live my full potential and have an amazing day.
3. I see the potential in others, and they see the potential in me.

MINI MEDITATION AND VISUALIZATION

Close your eyes and get comfortable. Take several deep breaths and notice how each breath starts small and then fills your lungs. See yourself walking into a beautiful garden. There is a tiny seed emerging from the ground. Become aware of its potential. Smile and tell it, "You can become anything you want." Then watch it slowly grow larger, see the sun shining on it and giving it strength. Watch it open up into a small flower. Leaves grow from the stem. The flower brightens in color then becomes larger and more detailed and beautiful. Feel amazement at this process and watch it become the most beautiful flower in the garden. See its beauty and magnificence radiating outward and shining on all the other plants. See it shining on you in thanks for the encouragement you gave it. When you open your eyes, know that there is potential in all things, including yourself, and in the right environment with the right support, full potential can be realized.

> "Whatever there be of progress
> in life comes not through
> adaptation but through daring."
> ~ HENRY MILLER

COLORING TIP

Choose an affirmation and repeat it three times as you begin to color each progress section in the illustration.

AFFIRMATIONS

Choose an affirmation and repeat several times daily, or during meditation:

1. Every step, no matter how small, is progress.
2. I celebrate my progress along the way with gratitude for what I have achieved and determination for what is to come.
3. Where there is progress, there is success.

MY PROGRESS LIST

Pick one thing from your To Do list and break it down into tiny steps. As you complete each step, cross it off or put a smiley face next to it. *For example, "Clean the kitchen" could be broken down to: throw out old food, unload the dishwasher, wash the floor, wipe down surfaces, scrub pots and pans, clean the microwave.* That way if you don't get to do all of those things, you can still cross things off your list and feel like you're making progress.

TASK:

...

PROGRESS STEPS:

1. ...
2. ...
3. ...
4. ...
5. ...

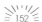

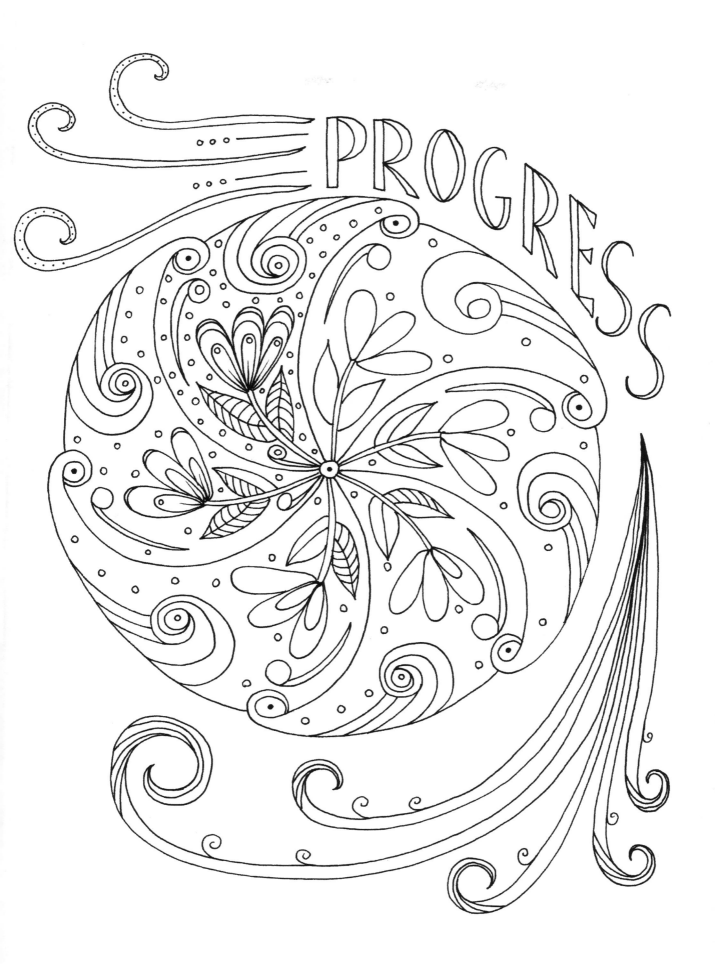

> "The purpose of art is washing the
> dust of daily life off our souls."
> ~ PABLO PICASSO

AFFIRMATIONS

Choose an affirmation and repeat several times daily, or during meditation:

1. My purpose is what I choose it to be. I have the power to live any life I have imagined.
2. I can find purpose in each and every moment.
3. I love being filled with a clear sense of purpose as I participate in life.

Just as you can feel as though you have an overall purpose in your life, you can choose to have a different purpose each day or each week. *For example, you could say to yourself, "Today my purpose is to be helpful to others in any way I can."* Focusing on a specific purpose makes you more aware of opportunities related to it, rather than trying to be everything to everyone all the time.

MY PURPOSE STATEMENTS

Write down a few ideas and examples of purposes you would like to focus on, then at the start of each day or week decide what you would like your purpose to be. *For example, to be a creative ideas machine, to make others feel valued, to be an example of good health, to be a good listener.*

TODAY MY PURPOSE IS ..

THIS WEEK MY PURPOSE IS ..

THIS MONTH MY PURPOSE IS ..

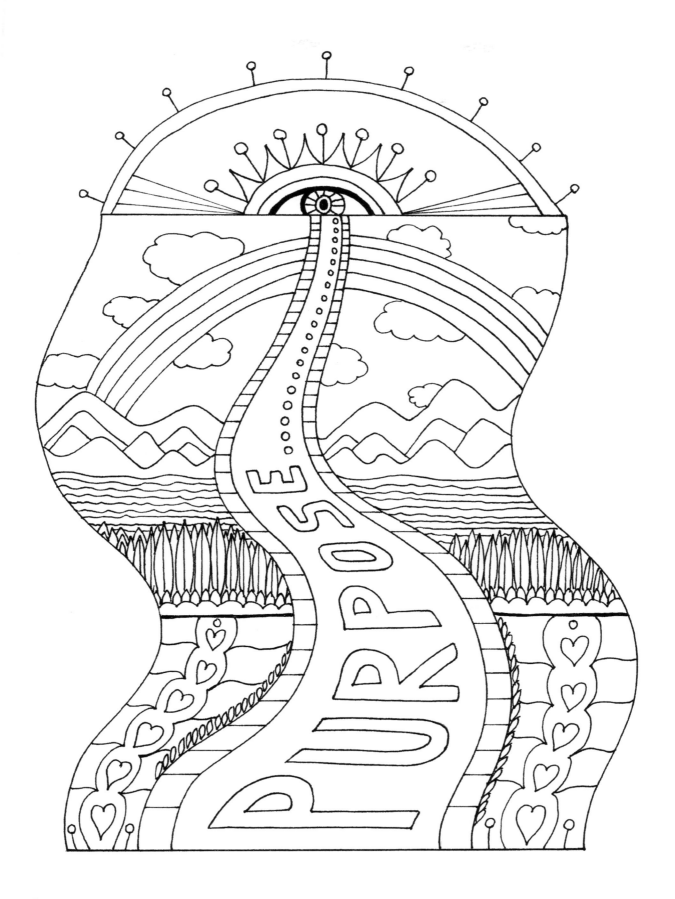

> "Asking is the beginning of receiving.
> Make sure you don't go to the ocean
> with a teaspoon. At least take a bucket
> so the kids won't laugh at you."
> ~ JIM ROHN

COLORING TIP

As you color, imagine what you would like to receive, and visualize it being given to you in the box.

AFFIRMATIONS

Choose an affirmation and repeat several times daily, or during meditation:

1. I am ready to receive all that I desire.
2. When I relax and get happy, I know that I am in receiving mode.
3. I am blessed to be continually giving and receiving.

GIVING AND RECEIVING LIST

Think of three things you'd like to receive in your life right now and write them down. Then, think of ways you could give those things to someone else as well. By giving, you receive. *For example, if you would like to receive more financial abundance, you could give someone a gift card or buy them dinner. Or if you would like to receive more affection, you could be more affectionate to others, even in simple ways like a light touch of the hand.*

I'D LIKE TO RECEIVE...

1. ..
2. ..
3. ..

I CAN GIVE THESE THINGS TO OTHERS BY...

1. ..
2. ..
3. ..

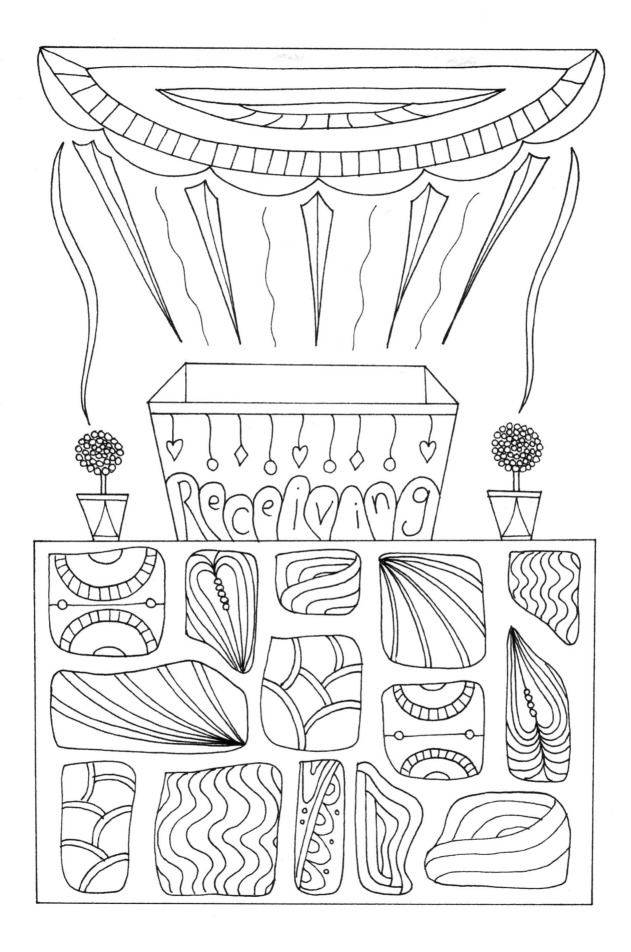

> "A cheerful frame of mind, reinforced
> by relaxation...is the medicine that
> puts all ghosts of fear on the run."
> ~ GEORGE MATTHEW ADAMS

COLORING TIP

Put on some relaxing music, burn some relaxing aromatherapy oil, and enjoy the relaxation of coloring the illustration.

AFFIRMATIONS

Choose an affirmation and repeat several times daily, or during meditation:

1. The more I focus on my breath, the more I relax and feel at ease.
2. Relaxation time is important to me and I am entitled to it.
3. I move through my day with a relaxed efficiency.

MINI MEDITATION

Get into a relaxing position and close your eyes, make sure you are a comfortable temperature and not likely to be interrupted. Take three deep breaths and feel your tension melting away. If you could be relaxing anywhere in the world, in any place, in any way, where would you be and what would you be doing? Use your imagination to take you to your ideal relaxation place. Even if you haven't been there before, imagine what you think it will look and feel like. Use your five senses and imagine all the sensory details as though you are really there. Be creative and indulge in this moment of relaxation, knowing you deserve it. Spend as long as you like in this visualization and feel the benefits of relaxation as your mind and body calm down.

RELAXATION TO DO LIST

For example, taking a bath, getting a massage, reading for an hour before bed.

THIS WEEK I WILL RELAX BY...

1. ..
2. ..
3. ..

> "You leave old habits behind by starting out with the thought, 'I release the need for this in my life.'"
> ~ DR. WAYNE W. DYER

AFFIRMATIONS

Choose an affirmation and repeat several times daily, or during meditation:

1. I choose to release all beliefs and habits that no longer serve me.

2. With this exhalation, I release all tension from my body.

3. By releasing the old, I make room for the new.

RELEASE RITUAL

Use this ritual to release old hurts and beliefs from your mind.

Write down three things that have troubled you, either limiting beliefs that interfere with achieving your dreams, and/or difficult experiences you've been through. First write the belief or experience down, then below it write a new belief, or something positive you learned or experienced from the difficulty. *For example, the belief "I'll never have enough money" could become "I'm becoming more abundant every day." If you experienced a difficult relationship breakup, you could write that you learned how to stand up for yourself or that you had many happy memories despite the challenges.*

1. ..
..

2. ..
..

3. ..
..

Pretend you are picking up the old belief or the difficult experience from the page with your hand. Hold your hand in front of you, palm facing up. Then say "I now release this" and blow the belief or experience off your hand and away, feeling it disappearing from your mind. You may like to also cross it off the page. Then say the new belief or what you learned, and smile at the feeling of relief and lightness.

> "Romance is the glamour which turns the dust of everyday life into a golden haze."
> ~ CAROLYN GOLD HEILBRUN

COLORING TIP

As you color the flowers, focus on a romantic gesture you'd love to receive. As you color the hearts, focus on a romantic gesture you'd love to give.

AFFIRMATIONS

Choose an affirmation and repeat several times daily, or during meditation:

1. I am worthy of romance and excited to experience its charm.
2. I can make everyday activities romantic if I choose.
3. I give and receive romantic gestures that put a smile on my face.

ROMANTIC GESTURES TO GIVE AND RECEIVE

Write a list of gestures you find romantic that you would like to give to someone special and/or receive yourself. *For example, leaving a cute Post-it message for someone special to find, sending a text message to say "I'm thinking about you," having a candlelit dinner.*

1. ..
2. ..
3. ..
4. ..
5. ..

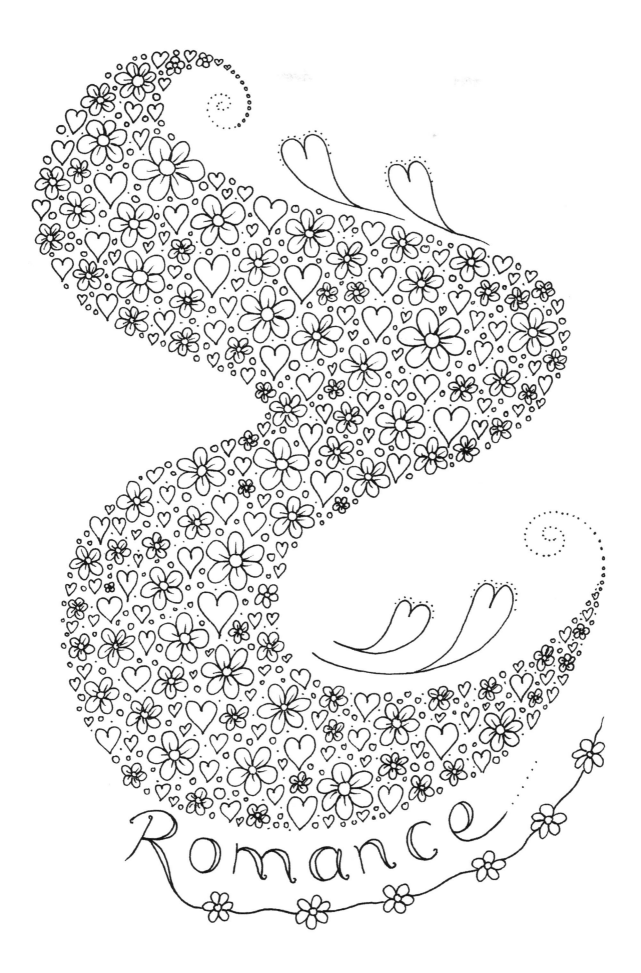

> "Persistence and resilience only come
> from having been given the chance
> to work through difficult problems."
> ~ GEVER TULLEY

COLORING TIP

Repeat one of the affirmations periodically as you color the illustration.

AFFIRMATIONS

Choose an affirmation and repeat several times daily, or during meditation:

1. I am strong, capable, and resilient.
2. I can and I will rise from every challenge.
3. Resilience is natural to me and I know I will be all right.

EXAMPLES OF MY RESILIENCE

List times in your life when you've shown resilience. *For example, recovering after a long illness, getting back to dating after a relationship breakup, looking for a new job after losing one.*

1. ...
2. ...
3. ...

Know that you are stronger and more resilient than you may give yourself credit for. Trust that you can handle any challenge that comes your way, and promise to never give up on your hope, determination, and persistence.

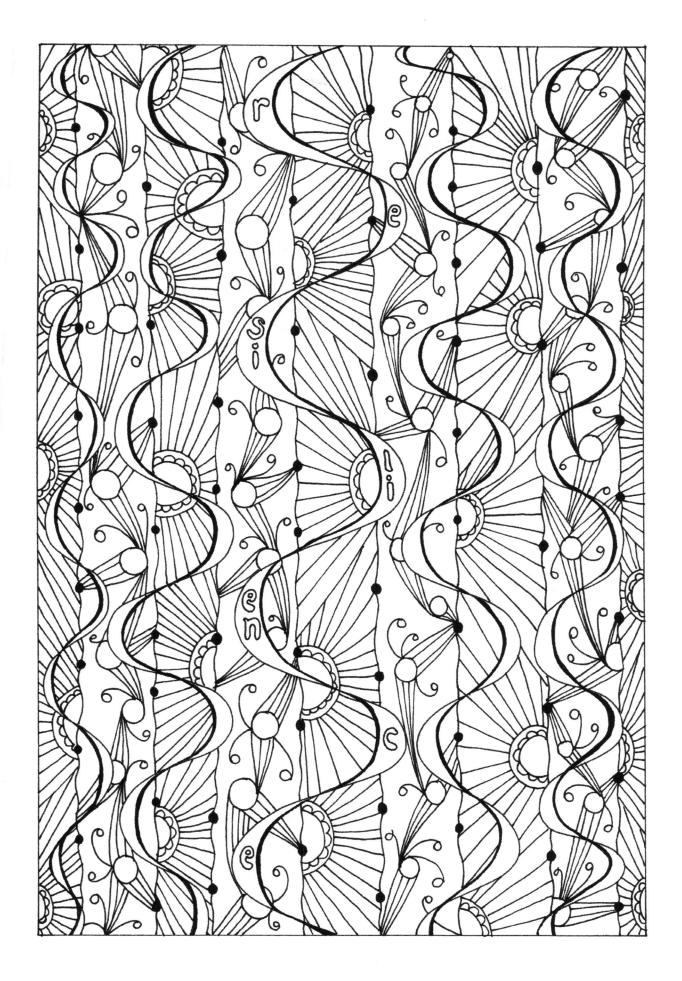

> "Intellectual passion drives
> out sensuality."
> ~ LEONARDO DA VINCI

AFFIRMATIONS

Choose an affirmation and repeat several times daily, or during meditation:

1. I am in touch with and celebrate my own sensuality.
2. I can feel sensual whenever I choose.
3. I move with a natural rhythm and flow that radiates sensuality.

THREE TIPS TO EMBRACE SENSUALITY

1. Wear clothing that highlights your best features and makes you feel attractive.
2. Observe the sensuality of nature: the ebb and flow of waves, the gentle rustling of leaves, the smooth movements of an animal, etc.
3. Explore the power of touch by giving or getting a massage.

COMPLETE THIS SENTENCE

I FEEL SENSUAL WHEN I...

1. ..
2. ..
3. ..

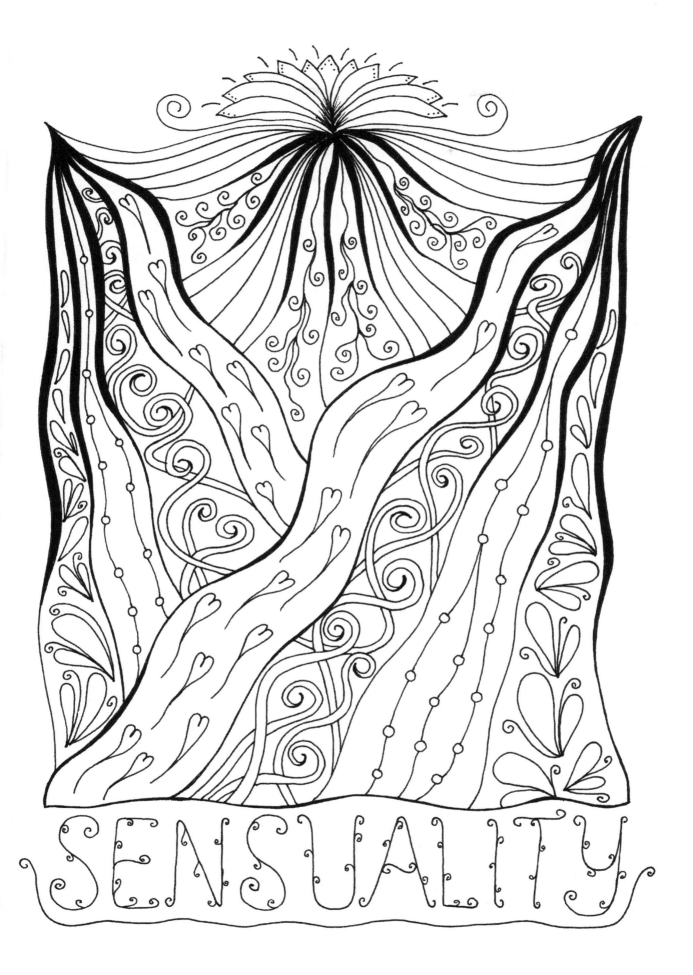

> *"Most discoveries even today
> are a combination of serendipity
> and of searching."*
> ~ SIDDHARTHA MUKHERJEE

COLORING TIP

As you color, repeat one or all of the affirmations and get excited knowing that serendipity is at play in your life.

AFFIRMATIONS

Choose an affirmation and repeat several times daily, or during meditation:

1. I take notice of signs from the universe and act on them.
2. Everything happens for a reason, and I trust the process of life.
3. My life is filled with magical moments of serendipity that let me know I'm on the right path.

EXAMPLES OF SERENDIPITY

List interesting coincidences you've experienced in your life, or unexplained moments or signs that somehow felt like a greater force, or fate, was at play. *For example, seeing someone after thinking of them, knowing who was on the phone before you answered it, seeing the same numbers in different places.* If you can't think of any, start noticing them in your life and write them down when they appear.

1. ..
2. ..
3. ..

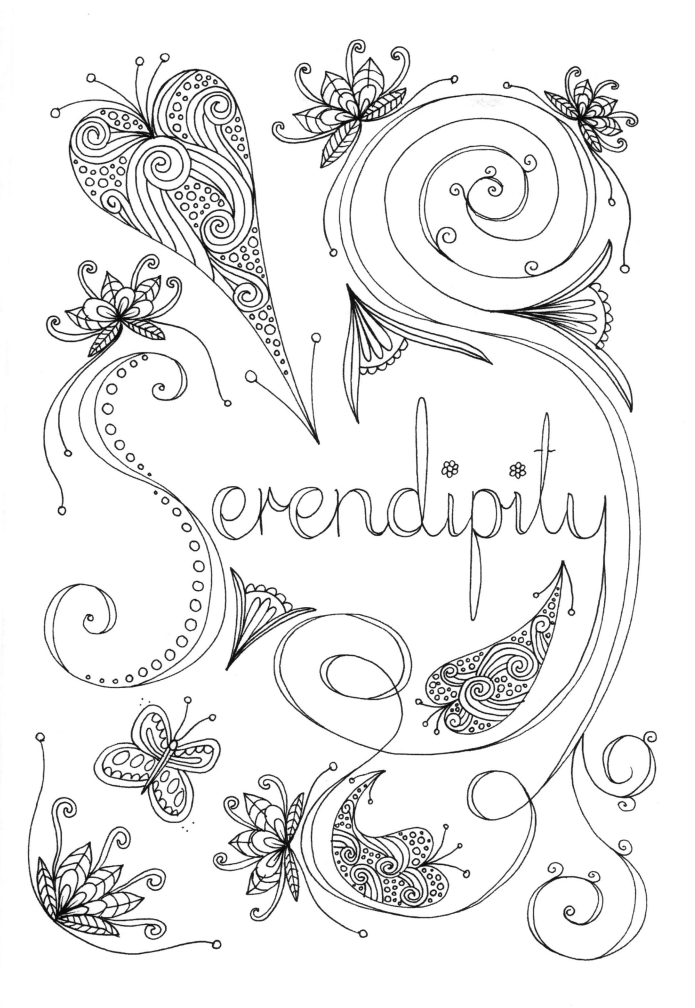

> "People are like stained-glass windows. They sparkle and shine when the sun is out, but when the darkness sets in, their true beauty is revealed only if there is a light from within."
> ~ ELISABETH KÜBLER-ROSS

COLORING TIP

Repeat one or all of the affirmations as you color to enhance self-confidence and belief in your own positive impact on the world.

AFFIRMATIONS

Choose an affirmation and repeat several times daily, or during meditation:

1. I am ready to be seen and appreciated. It's my time to shine.
2. My natural beauty and charm shine from within.
3. I will shine a reassuring light on those who need it today.

MINI MEDITATION

Do the following candle meditation whenever you need encouragement or confidence to express yourself or do your best.

Find a dark room and light a candle. Sit in front of the candle and watch it glow. Imagine the candle is shining a light on your gifts, talents, and skills. What do you see? Now imagine you are the candle, and the flame is your light shining onto the world. It is your choice whether to just be the candle, or whether to light your flame as well. When you are shining your light, what are the benefits others receive? Visualize people being impacted positively by your gifts, and know that it is okay to let yourself shine and be recognized.

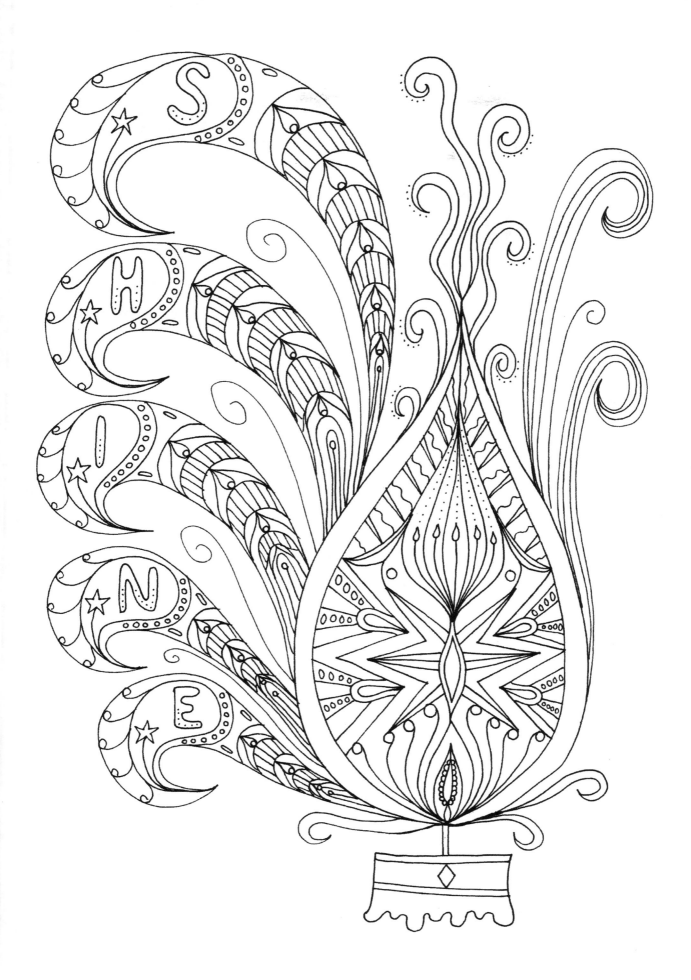

> "Birds sing after a storm; why shouldn't people feel as free to delight in whatever sunlight remains to them?"
> ~ ROSE KENNEDY

COLORING TIP

As you color, listen to songs and sing along to them, without worrying what you sound like.

AFFIRMATIONS

Choose an affirmation and repeat several times daily, or during meditation:

1. With my voice I can release tension, fears, and emotions.
2. I look forward to the bliss of singing along to songs I hear today.
3. I am grateful for the gift of song.

Tip: You can even try singing your affirmations.

MY FAVORITE SONGS TO SING ALONG TO

Singing is a powerful way to connect with your heart and soul and to express your emotions. It is also good for your lungs and airways. Make a list of songs that make you feel good and always make you want to sing along, and when you need a boost, listen to them and sing your heart out.

1. ...
2. ...
3. ...
4. ...
5. ...

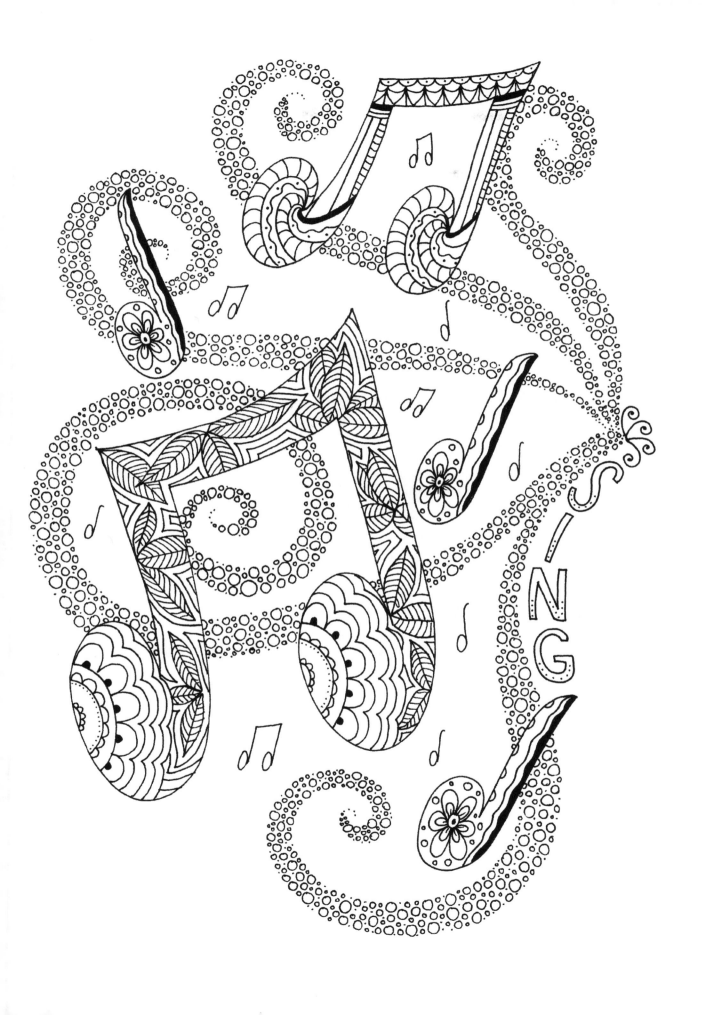

> "Put your heart, mind, and soul
> into even your smallest acts.
> This is the secret of success."
> ~ SWAMI SIVANANDA

COLORING TIP

If your soul had colors, what would they be? Instinctively choose a few colors you are drawn to, and color the illustration.

AFFIRMATIONS

Choose an affirmation and repeat several times daily, or during meditation:

1. When I need to make a decision, I listen to my heart and soul.
2. My soul is connected to all living things and I am supported in all I do.
3. Today I choose not only to see with my eyes, but with my soul.

FIVE WAYS TO CONNECT WITH YOUR SOUL

1. Meditation. Use a guided audio recording if needed, or relaxing music.
2. Chanting, mantras, or prayer. Use your voice and repetition.
3. Automatic writing. Write continually in a journal any thoughts that come to mind without censoring yourself.
4. Get into nature and connect with the earth, as your soul is an extension.
5. Float in water and feel the sensation of weightlessness. This makes it easier to focus on the sensation of the non-physical part of you.

Finish this sentence by writing down the first answer that comes to mind:
Today, my soul is telling me to...

..

..

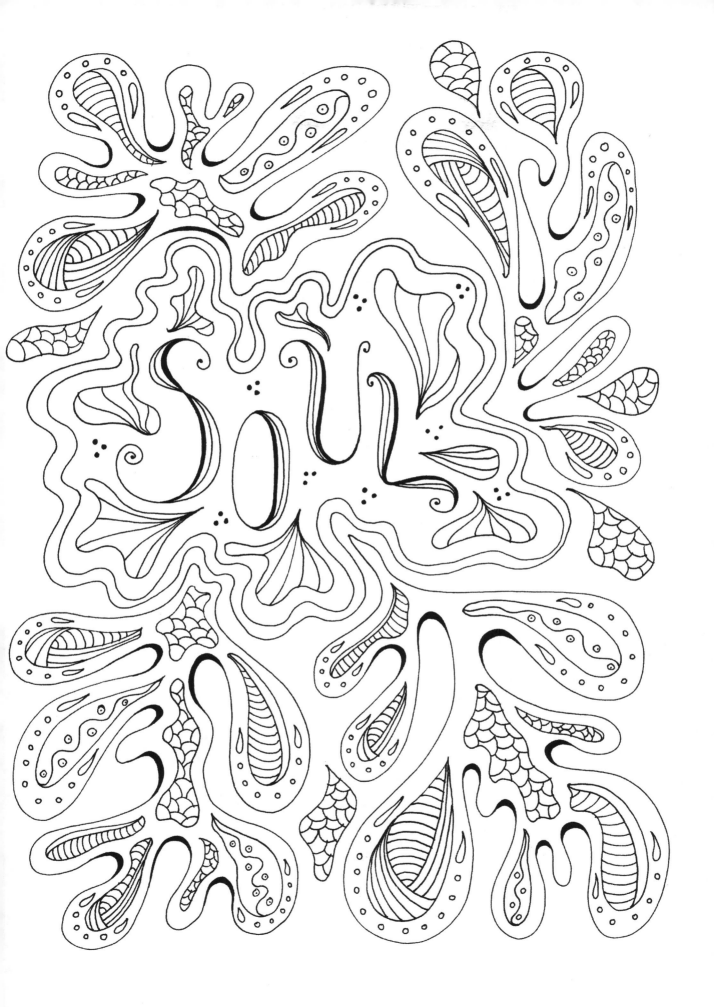

> "The minute I heard my first love story I started looking for you, not knowing how blind that was. Lovers don't finally meet somewhere. They're in each other all along."
> ~ RUMI

COLORING TIP

Color sections with a different color allocated for each quality you seek in your soul mate. If you are already with your soul mate, focus on qualities you love about him or her as you color.

AFFIRMATIONS

Choose an affirmation and repeat several times daily, or during meditation:

1. I am now ready to meet my soul mate.
2. I am excited about meeting and getting to know my ideal partner.
3. I enjoy preparing myself for my ideal relationship.

MY SOUL MATE

If you were in a relationship with your ideal partner, how would you describe him or her? Make a list. Be specific and positive. *For example, if you want a nonsmoker, write "follows healthy lifestyle habits" instead of "nonsmoker."* Be open to the possibility that your soul mate might not have every single quality you seek, or may have others you haven't thought about. *For example, kind, generous, affectionate, calm under pressure, funny.*

1. ..
2. ..
3. ..
4. ..
5. ..

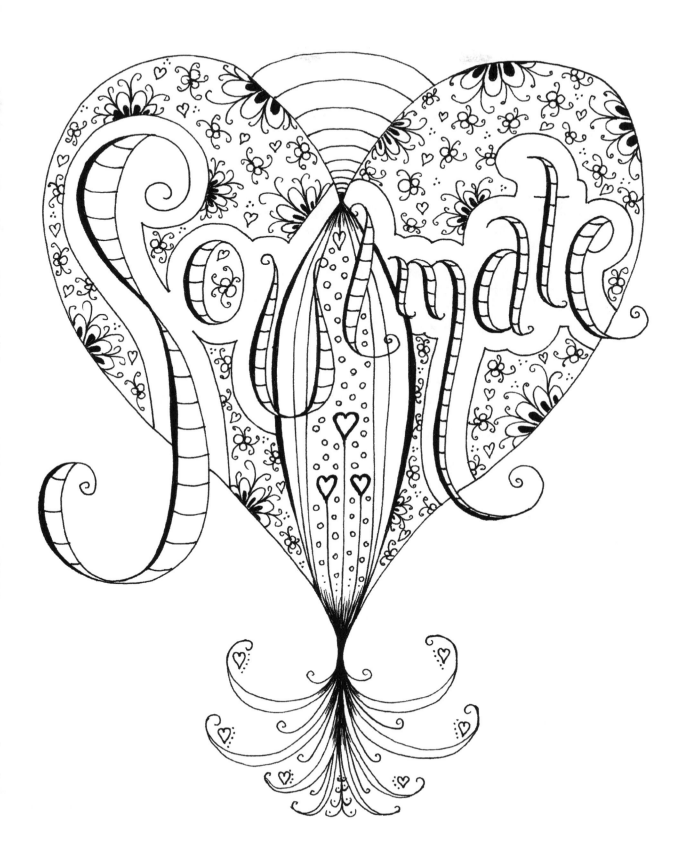

> "You have power over your mind—
> not outside events. Realize this,
> and you will find strength."
> ~ MARCUS AURELIUS

COLORING TIP

As you color each section of the pillars, imagine the color as extra strength building up inside of you, whether physical, emotional, mental, or all three.

AFFIRMATIONS

Choose an affirmation and repeat several times daily, or during meditation:

1. I have more strength inside than I realize. It is there whenever I need it.
2. The stronger I get, the stronger I get. I will keep going.
3. I am supported, I am safe, I am strong.

THREE WAYS I AM STRONG

List ways you are strong in your life, or times you have shown strength, either physical, emotional, or mental. *For example, raising a child on my own, lifting more weights at the gym, standing up for myself.*

1. ...
2. ...
3. ...

COMPLETE THIS SENTENCE:

For example, dealing with parenthood, sticking to my exercise routine, dealing with a broken heart.

I WOULD LIKE MORE STRENGTH WITH...

1. ...
2. ...
3. ...

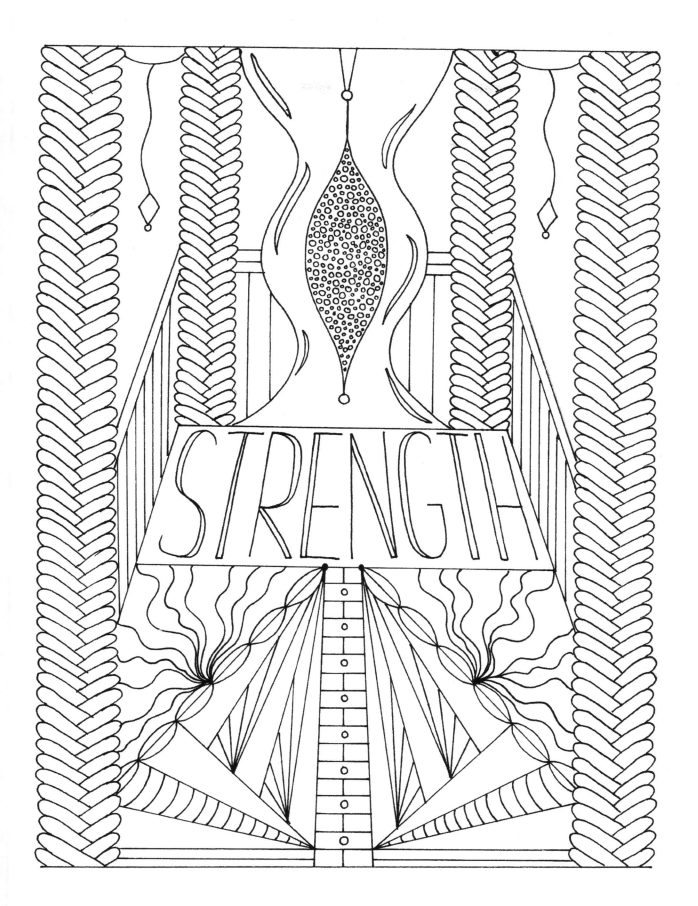

> "I've failed over and over and over again in my life. And that is why I succeed."
> ~ MICHAEL JORDAN

AFFIRMATIONS

Choose an affirmation and repeat several times daily, or during meditation:

1. If I am happy, I am successful.
2. I can be successful at anything I choose.
3. I am worthy and deserving of success.

MINI MEDITATION

Close your eyes and relax your body by taking several deep breaths. Think of past successes in your life, then imagine yourself stepping up onto a podium or stage and receiving applause from the crowd for your successes. Repeat an affirmation such as "I can be successful at anything I choose" as many times as you like, then imagine yourself stepping off the podium and applauding someone else who has now taken center stage.

THREE WAYS I AM SUCCESSFUL

List examples of your success in life.

1. ..
2. ..
3. ..

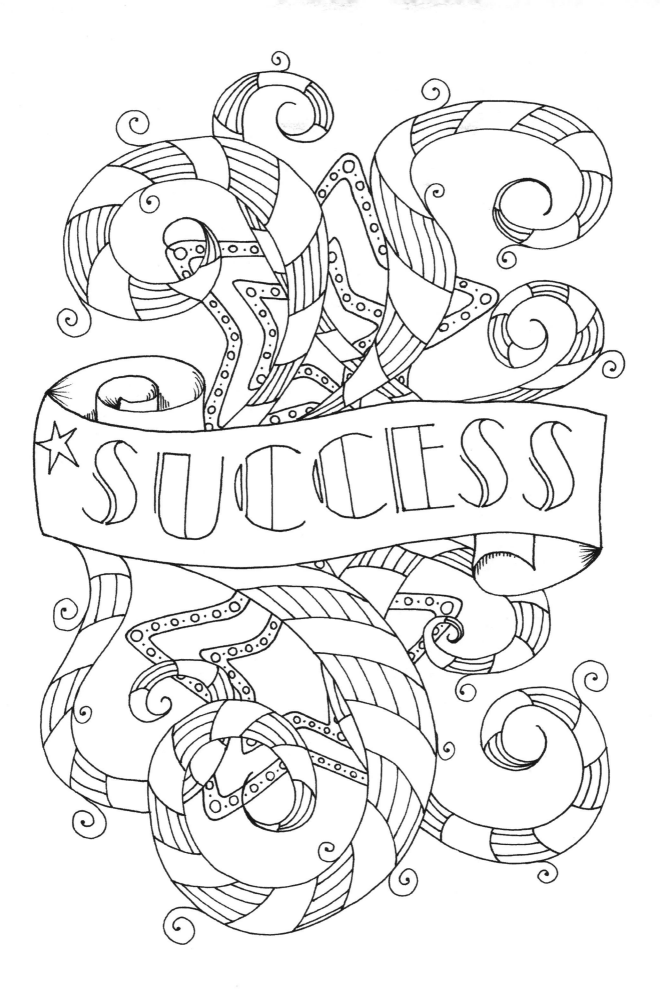

> "If you have pendulum clocks on the wall and start them all at different times, after a while the pendulums will all swing in synchronicity. The same thing happens with heart cells in a Petri dish: they start beating in rhythm even when they're not touching one another."
> ~ BRUCE LIPTON

AFFIRMATIONS

Choose an affirmation and repeat several times daily, or during meditation:

1. Things happen to me at perfect, synchronistic times.
2. I am aware and open to experiencing moments of synchronicity.
3. Miraculous moments of synchronicity aligned with my desire occur frequently.

SYNCHRONICITY IN MY LIFE

Think of a desire, goal, or purpose you've focused on in your life, and list examples of synchronistic moments, coincidences, or other experiences aligned with your desire that showed up for you to confirm you were on the right path. *For example, hearing a song with lyrics that relate to what you are wanting, seeing words on a T-shirt that you had spoken or heard recently.*

If you can't think of any experiences like this, state a goal or desire, then as you start using the techniques in this book, note down synchronistic moments as they occur.

1. ..
2. ..
3. ..

Synchronicity is similar to serendipity. Synchronicity, however, is more about things working together, alongside each other, in a synergistic way. Moments become like dance, a beautiful series of events that together create a flowing order of experiences that link to each other.

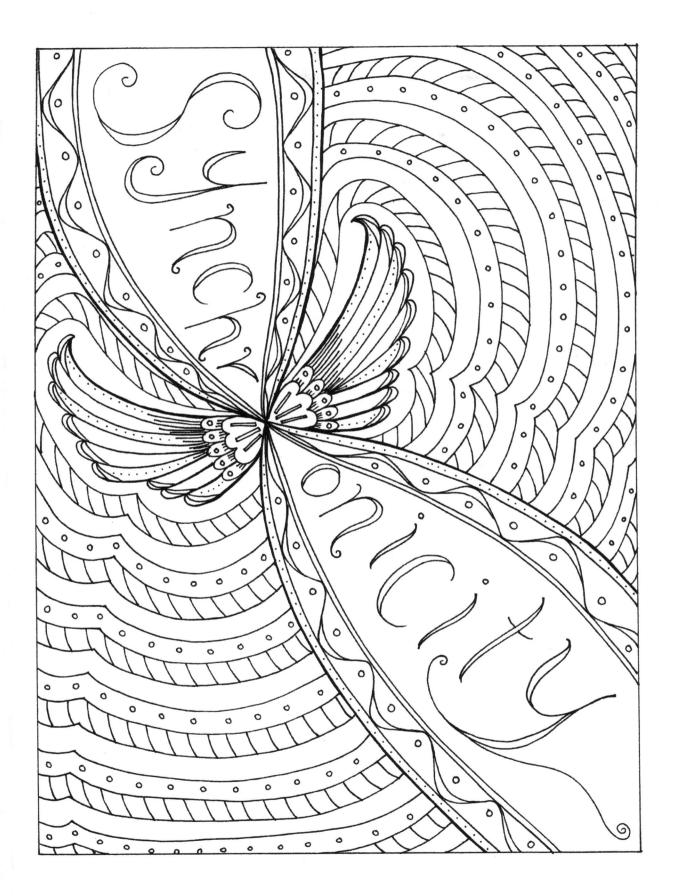

> "My mission in life is not merely to survive, but to thrive; and to do so with some passion, some compassion, some humor, and some style."
> ~ MAYA ANGELOU

AFFIRMATIONS

Choose an affirmation and repeat several times daily, or during meditation:

1. I will live a life not just to survive, but to thrive.
2. Thriving is my natural state of being.
3. When I surround myself with positive people and experiences, I thrive.

THREE WAYS TO THRIVE

1. Don't just eat food to survive. Eat healthy food to thrive.
2. Don't settle for second best. Take conscious, deliberate, and inspired action to go for what you want and deserve.
3. Don't just relax with television or surfing the Internet. Give your mind a proper break through meditation or relaxation exercises.

I AM THRIVING WHEN I...

List how things look when you are thriving. *For example, I am thriving when I am enjoying my exercise routine, when I am able to see the positive in challenging situations, when I look forward to eating healthy food.*

1. ..
2. ..
3. ..

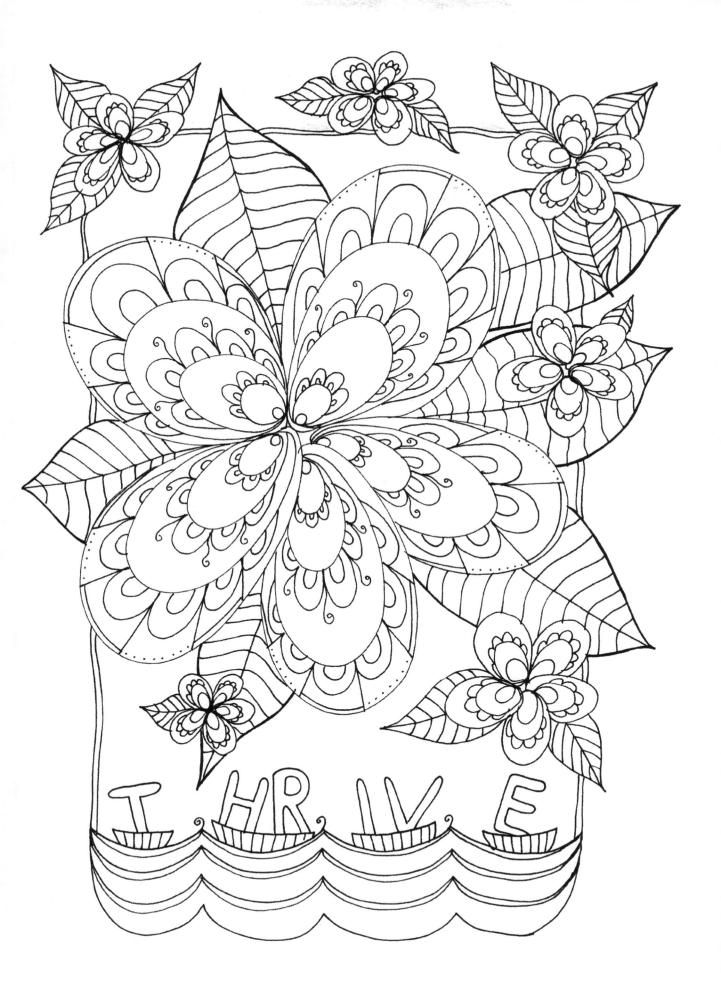

> "Personal transformation can and does have global effects. As we go, so goes the world, for the world is us. The revolution that will save the world is ultimately a personal one."
> ~ MARIANNE WILLIAMSON

AFFIRMATIONS

Choose an affirmation and repeat several times daily, or during meditation:

1. I am ready to undergo a positive transformation, and I eagerly begin now.

2. I can transform my mind, body, and life through the power of my thoughts.

3. Life is a continual process of transformation, and I am enjoying every minute of it.

COMPLETE THIS SENTENCE

For example, body, finances, career, lifestyle, relationship.

Right now, my,, and are undergoing a positive transformation.

MINI MEDITATION

Close your eyes and take several deep breaths. Notice how your inhalation transforms into an exhalation with ease. Imagine a cocoon breaking open gently and a butterfly emerging, flying around, sharing its beauty with the world. Feel appreciation for this creature and the process of transformation that made it possible. Now imagine yourself emerging from a cocoon. What is the best version of you? Rather than focus on what you might look like, focus on how you would feel. Feel your potential and the gift that transformation can bring. Say to yourself, "I am ready to undergo a positive transformation, and I eagerly begin now."

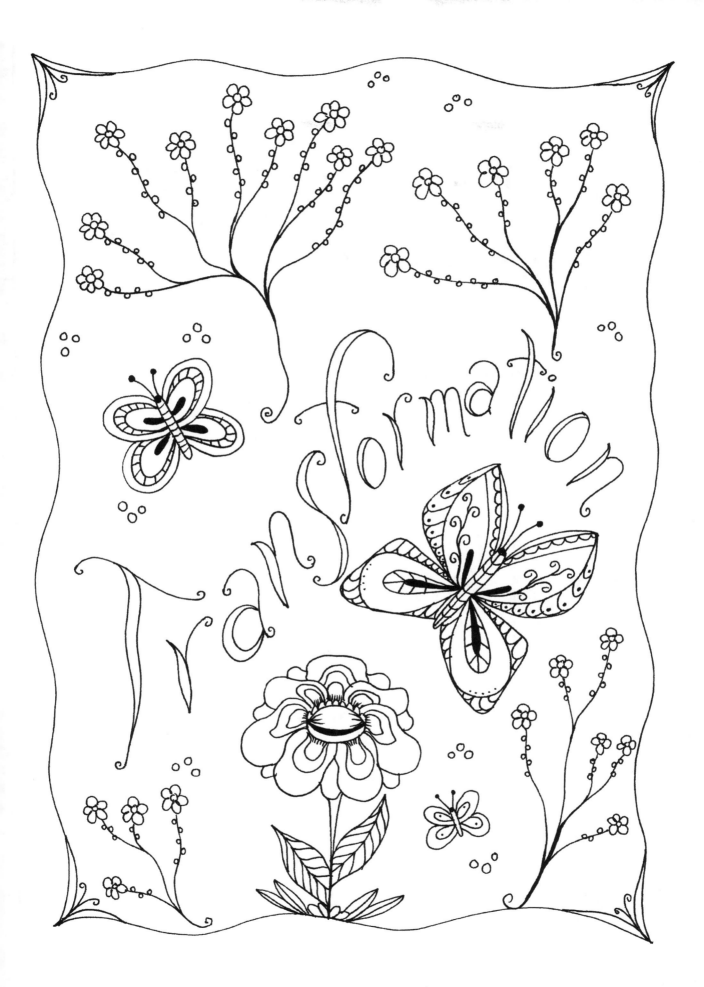

> "Trust yourself. You know more
> than you think you do."
> ~ BENJAMIN SPOCK

COLORING TIP

Allocate a different color for each affirmation, and as you color, repeat the affirmation in your mind or say it out loud.

AFFIRMATIONS

Choose an affirmation and repeat several times daily, or during meditation:

1. I trust that life is unfolding perfectly for me.
2. I trust in the healing power of my mind and body.
3. I am ready to trust myself and follow my instincts.

THREE WAYS I CAN SHOW MORE TRUST

List ways you can demonstrate that you have trust. *For example, letting someone else make a small decision for you, having a "go with the flow" day without strict plans, listening to your gut instinct.*

1. ..
2. ..
3. ..

THREE EXAMPLES OF THE POWER OF TRUST

List times in your life when things have worked out unexpectedly well. *For example, getting a flight upgrade, finding a parking spot during a busy time, getting stuck in a long line but meeting an old friend and catching up with them.*

1. ..
2. ..
3. ..

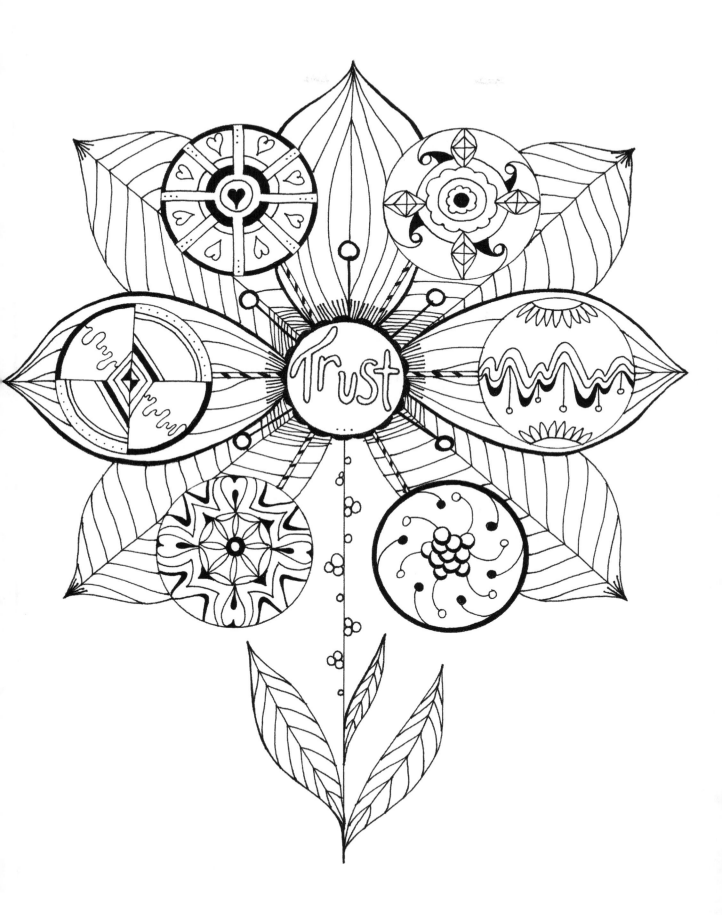

> "Honesty is the first chapter
> in the book of wisdom."
> ~ THOMAS JEFFERSON

AFFIRMATIONS

Choose an affirmation and repeat several times daily, or during meditation:

1. Whether I perceive the truth as good or bad is up to me.
2. I seek to live a life of honesty and truth.
3. I embrace the truth of who I am.

REASSURING TRUTHS

When we're feeling uncertainty about a situation, we tend to overthink or overanalyze. Did we say the wrong thing? Are they plotting something? Is this going to turn out badly? Write down the truth you know about the situation or person, and even yourself. The facts, not your opinion or fears. When you find yourself overthinking, refer to your list of truths and be reassured that it is often not as bad as you may think.

SITUATION:

...

TRUTHS:

1. ...
2. ...
3. ...

To attract honesty and truth, demonstrate honesty and truth. Make a list of ways you can embody honesty or times you have spoken your truth. *For example, give constructive criticism, ask for a better deal, give a genuine compliment.*

1. ...
2. ...
3. ...

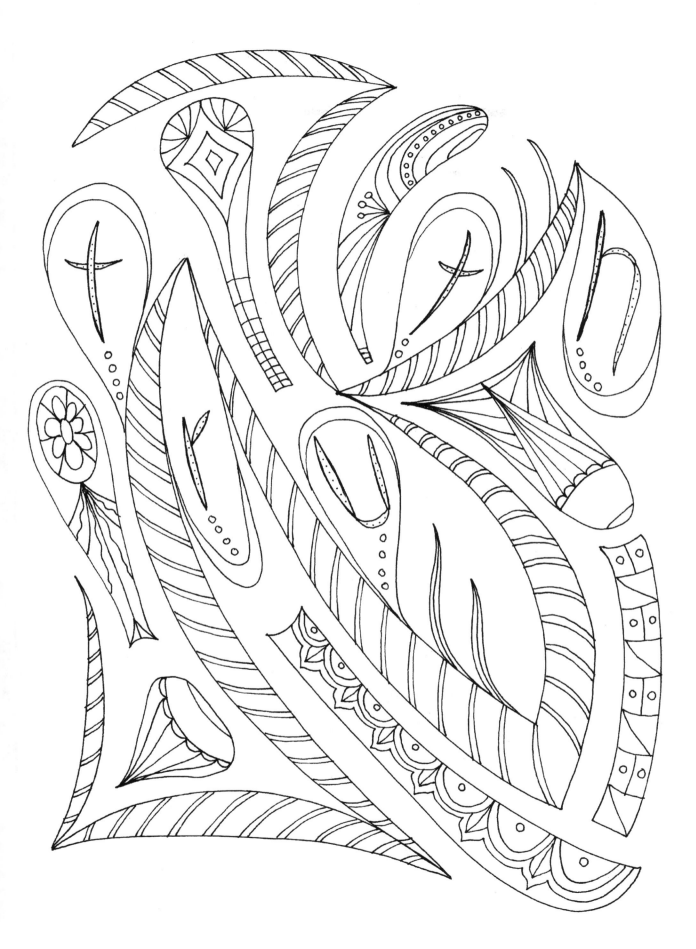

> "When you really listen to another person from their point of view, and reflect back to them that understanding, it's like giving them emotional oxygen."
> ~ STEPHEN COVEY

COLORING TIP

As you color, think of a certain person you would like to understand better, or someone you didn't understand before but now do. See each color as a representation of your understanding and acceptance of them.

AFFIRMATIONS

Choose an affirmation and repeat several times daily, or during meditation:

1. By understanding myself, I can understand others. The more I understand others, the more they will understand me.
2. I need not agree to understand.
3. Understanding is the basis of acceptance. I will seek to understand and accept.

THREE TIPS TO INCREASE UNDERSTANDING

1. Ask someone to tell you what their life or job is like.
2. Watch documentaries of different ways of life or different cultures.
3. Listen to interviews with interesting people to learn about different perspectives and experiences.

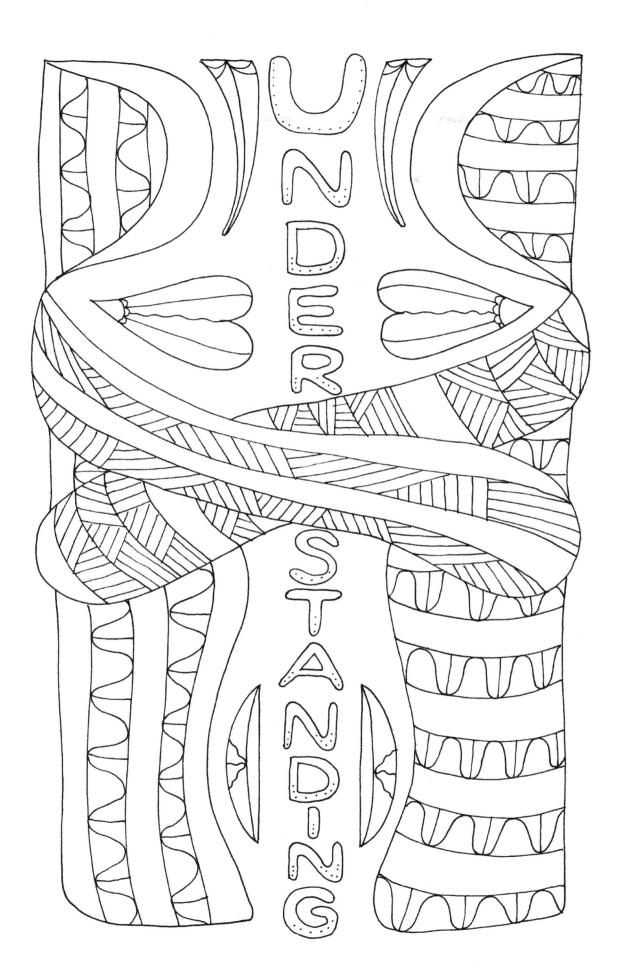

> "Vitality is radiated from exceptional art and architecture."
> ~ ARTHUR ERICKSON

COLORING TIP

After you have finished coloring the illustration, imagine the vitality radiating and transferring from the picture to your body.

AFFIRMATIONS

Choose an affirmation and repeat several times daily, or during meditation:

1. I wake with enthusiasm and vitality and can't wait to begin each day.
2. I am filled with so much vitality people ask me what my secret is.
3. Vitality is the natural result of my healthy commitment to myself.

VITALITY ALLOWS ME TO

Complete the sentence, "Vitality allows me to...", stating the things you would do if you had boundless energy and vitality. *For example, enter a marathon, go swimming, go for a run, play sports with my children or grandchildren.*

1. ..
2. ..
3. ..

THREE WAYS I CAN INCREASE MY VITALITY

For example, getting more sleep, eating a healthier diet, practicing a positive mindset, drinking less alcohol.

1. ..
2. ..
3. ..

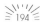

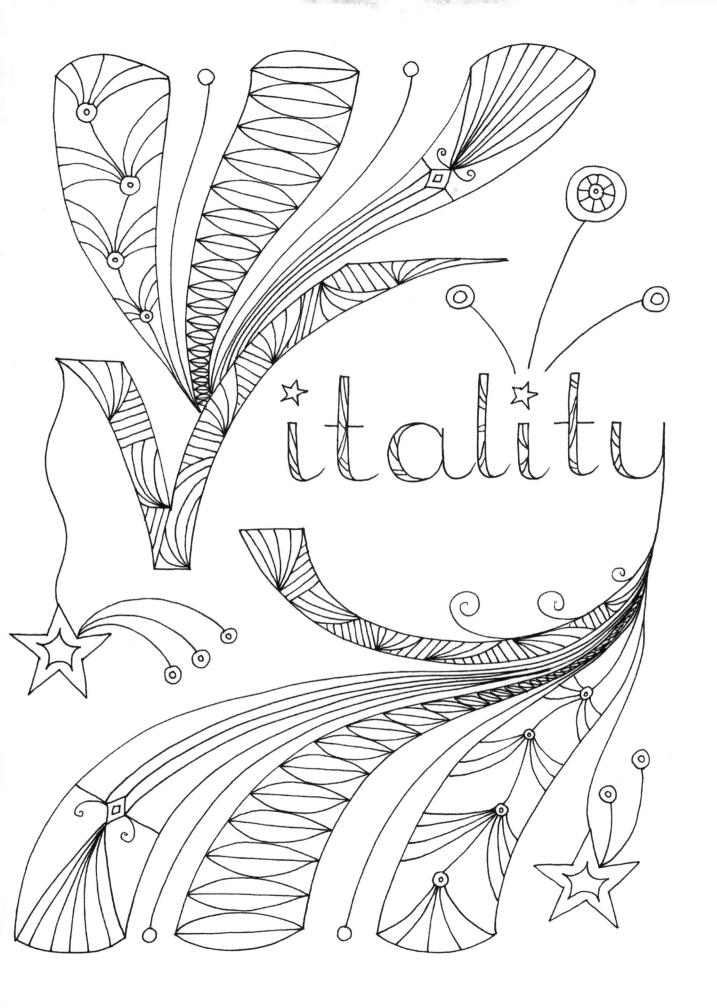

> "The part can never be well
> unless the whole is well."
> ~ PLATO

AFFIRMATIONS

Choose an affirmation and repeat several times daily, or during meditation:

1. I have access to unlimited well-being all the time.
2. Well-being is flowing to me continually and I receive it gratefully.
3. My first priority is my well-being and from that I have so much to give others.

THREE WAYS I CAN ENJOY MORE WELL-BEING

Write a list of things that would help you to feel a greater sense of well-being. *For example, spend time talking to a good friend, reading a positive book, watching a funny movie, doing something creative.*

1. ..
2. ..
3. ..

> "Knowledge comes, but wisdom lingers."
> ~ ALFRED, LORD TENNYSON

AFFIRMATIONS

Choose an affirmation and repeat several times daily, or during meditation:

1. Each day I gain wisdom that benefits me.
2. I trust my inner wisdom to lead me to where I need to be.
3. I see each challenge as an opportunity to gain more wisdom.

WISDOM I'VE GAINED IN MY LIFE

If someone were to ask you about three positive things you'd learned in your life, what would they be? *For example, to follow your heart, that things are always better in the morning.*

1. ..
2. ..
3. ..

THREE TIPS TO GAIN MORE WISDOM

1. Attend an educational and empowering workshop or seminar.
2. Participate in new experiences to add to your life experience.
3. Learn to meditate and listen to your inner wisdom.

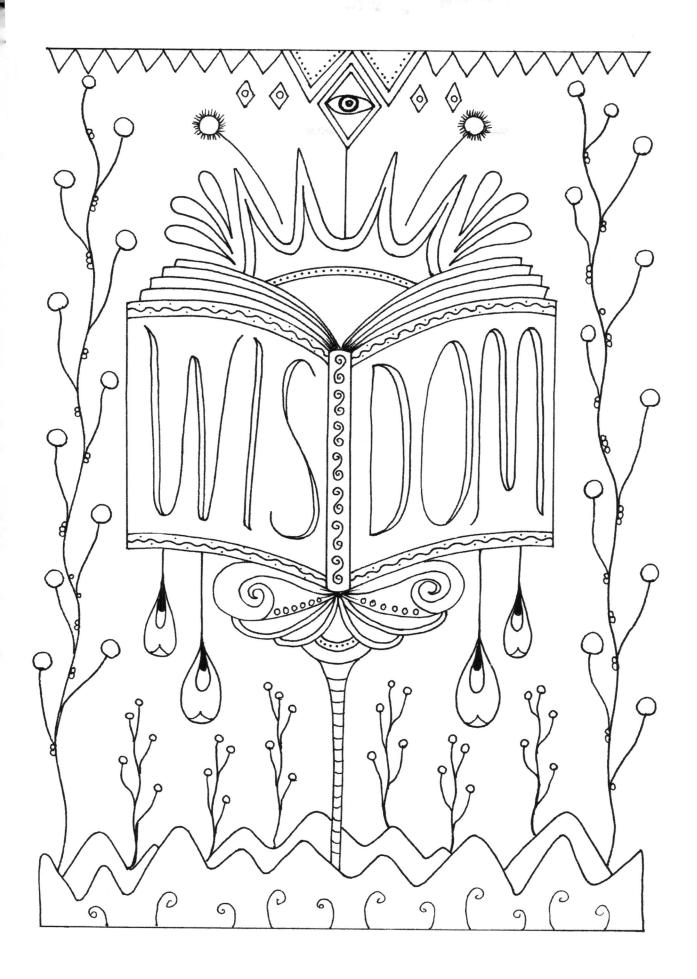

> "Life affords no higher pleasure than that of surmounting difficulties, passing from one step of success to another, forming new wishes and seeing them gratified."
> ~ SAMUEL JOHNSON

COLORING TIP

As you start coloring, make a wish. Think big and imagine you can wish for anything you want. What is one wish you would love to come true?

AFFIRMATION

Repeat this affirmation several times daily, or during meditation:

With belief, faith, and gratitude, wishes can come true.

MAKING WISHES COME TRUE

Write a list of wishes, for yourself and/or the world. Are there steps you could take to make them more likely to come true? For wishes on a global scale, what is one thing you could do to make a contribution? *For example, making a donation, volunteering.* If you don't know how you could make wishes come true, write the wish or wishes on a piece of paper and put it in an envelope with the intention for a greater power to handle. Or, light a candle and make your wish as you blow out the flame.

1. ...
2. ...
3. ...

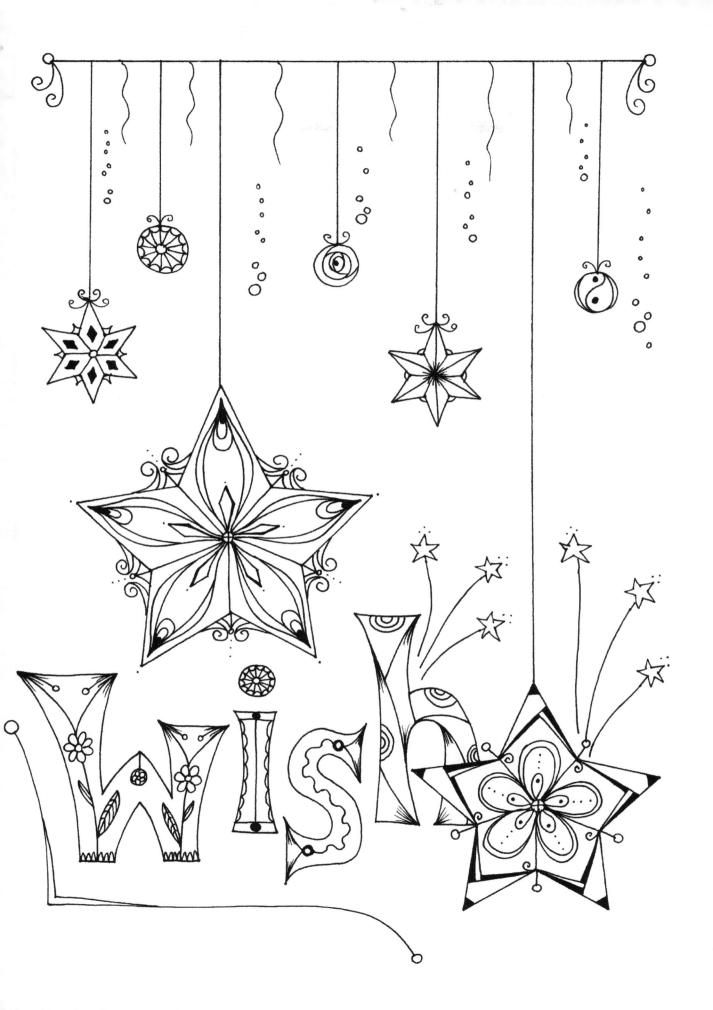

ACKNOWLEDGMENTS

As an author of fiction, I never imagined I would get an art book published, and to be able to combine my love of drawing with my love of words and self-empowerment is something I am truly grateful for.

Firstly, I'd like to thank my agent, Joelle Delbourgo for taking action on my coloring book idea and guiding me through crafting a proposal and ultimately securing publication. Many thanks to Anna Michels and the Sourcebooks team for seeing the potential in my concept, and for your enthusiasm and belief in the project. I'm so excited to be working with you and to be bringing this book to life!

I'd like to thank Johanna Basford whose success with her coloring books inspired me to try making my own, after my art skills had lain dormant for many years! I've rediscovered the joy of creating art.

And to the authors and teachers in the spiritual and self-help field who've inspired and enlightened me over the years through their work, thank you. Especially: Esther and Jerry Hicks (Abraham-Hicks, the Teachings of Abraham), Neale Donald Walsch, Cheryl Richardson, Dr. Wayne W. Dyer, Anita Moorjani, Janet Bray Attwood, Chris Attwood, and Louise Hay.

Thank you to my parents for their never-ending support and enthusiasm, both now and when I was a child who liked to draw and color and create things just because. Thank you for encouraging my creativity.

To my son, Jayden, thank you also for supporting your writer-artist-mother by saying my drawings were really good. I've taught you well! And thanks for inspiring me with your own creativity that blows me away.

To my friends, especially those who've been bombarded with multiple photos of my drawings shoved in front of them or messages asking for feedback and approval, thank you for your input and our fun chats, especially Julia, Cassie, Alli, and Diane. Thanks also to Ruth, for being both a valued friend and an accidental life coach! Our phone conversations and text messages are entertaining, motivating, and memorable. My life is richer with all of you in it.

And thanks to my readers and all the coloring enthusiasts out there for your support. I hope you enjoy this book and I wish you a colorful life with dreams that come true.

ABOUT THE AUTHOR

JULIET MADISON is an Australian bestselling and award-nominated author of fiction and an inspirational coloring book artist. In the past, she ran a successful business as a naturopath and health coach, empowering people with the tools to manage various health challenges on both a physical and emotional level.

A perpetual student of self-development, Juliet enjoys empowering books and courses that inspire a fulfilling, passionate life, and she loves writing her own motivational quotes and insightful reflections.

An avid artist from a young age, Juliet has qualifications in many fields in the fine arts, including drawing, painting, sculpture, photography, and hand-lettering. She is passionate about combining her love of words, art, and self-empowerment to create intricate, meaningful, uplifting designs to bring relaxation, inspiration, and creativity to others. She can be contacted via her website, www.julietmadison.com.